IMAGES
of America

BEMIDJI

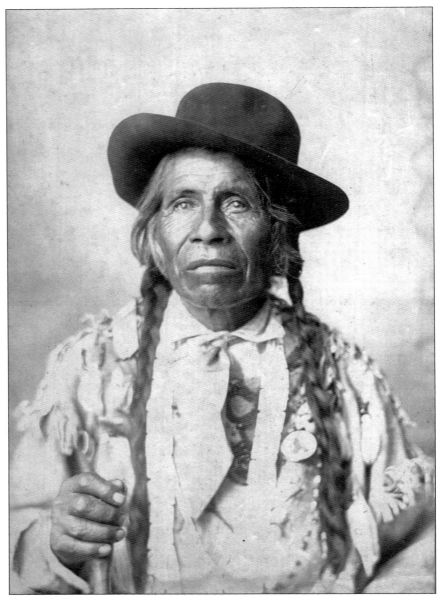

Shay-now-ish-kung is seen here with his ceremonial pipe in a posed Hakkerup Studio photograph. This was a popular genre of photograph at the time. Born about 1833, he saw many changes and tried to be a friend of both cultures. He was the leader of about 50 Indian people, and for that reason, he came to be respected and known as Chief Bemidji. (Courtesy of the Beltrami County History Center.)

ON THE COVER: Minnie J. Queen the dairy cow was brought up from Minneapolis to meet Babe the Blue Ox on June 29, 1930. The Bemidji Elks Band escorted Minnie from the American Legion clubhouse down to the lakeshore. Minnie was the product of National Dairy Month. Earl Grinols of the city council and Dr. A.C. Gilmer, president of the junior chamber of commerce, spoke at the ceremonies. (Courtesy of the Beltrami County History Center.)

IMAGES
of America

BEMIDJI

Cecelia Wattles McKeig

ARCADIA
PUBLISHING

Published by Arcadia Publishing
Charleston, South Carolina

Printed in the United States of America

Library of Congress Control Number: 2012954179

For all general information, please contact Arcadia Publishing:
Telephone 843-853-2070
Fax 843-853-0044
E-mail sales@arcadiapublishing.com
For customer service and orders:
Toll-Free 1-888-313-2665

Visit us on the Internet at www.arcadiapublishing.com

*To the many who made the Beltrami County History Center
a reality, and to those who continue to protect, nurture,
organize, and add to the extensive collection that is housed
in the historic Great Northern depot at Bemidji*

CONTENTS

ACKNOWLEDGMENTS

Since the Beltrami Historical Society was founded in 1952, dozens of dedicated staff and volunteers have contributed their time and expertise to preserve the history of the county. Without their hard work and their love of local history, this book would not have been possible. The society's manuscript collection and photograph collections offer access to information that is difficult or impossible to find elsewhere. Special thanks are due to the families and organizations that had the foresight and generosity to donate photographs and articles to the county museum so that they would be accessible to the public over the years. We should all remember that our scrapbooks, letters, and photographs could help some future researcher. We, as individuals and families, are all part of local history.

I would like to recognize the work of the Works Progress Administration in documenting much of our early history. Such an endeavor, and contemporary programs like the Minnesota Legacy Grants, enable us to organize, access, and save materials for future generations.

Thanks are extended to the editors and neighborhood columnists who faithfully supplied color and detail to the news reports of the day. These columns and editorials supply details about people and happenings that were not recorded anywhere else, and that tell stories about the small events in the lives of ordinary people.

I would like to thank Nicole Foss, our director, for sharing her knowledge and experience using the materials. Her encouragement and positive attitude spurred me to keep searching for the best photographs and information available. All the images in the book came from the collections of the Beltrami County History Center.

Thanks to my brother Phil Wattles, who helped search for photographs in the collection and made suggestions and corrections during the writing process. And finally, thanks to my family for accepting, if not quite understanding, my obsession for research and writing.

INTRODUCTION

Bemidji began with the establishment of the Carson trading post in 1888, on the east side of the Mississippi River outlet between Lake Bemidji and Lake Irving. The Carson brothers were befriended by Shay-now-ish-kung, who became known for the next 100 years as Chief Bemidji. Lumbering was at its peak in northern Minnesota. Logging camps sprang up throughout the countryside. John Steidl built his sawmill in 1894, not far from the Indian village and Carson's trading post, and his family became close friends with Shay-now-ish-kung. When there was a confrontation between the Army and the Bear Island Chippewa in October 1898, soldiers came to Bemidji and stayed until the danger had passed. Their tents were placed along what became Beltrami Avenue.

Bemidji was incorporated on May 20, 1896. Three newspapers advertised Bemidji's townsite lots. Businessmen saw the need for hotels and basic services. Guy Remore and his partner, George McTaggert, built the Grand Central Hotel, which evolved into the Hotel Remore. E.N. French built the City Hotel. Ole Anderson was the proprietor of the Lake Shore Hotel. Most were built near the railroad lines and the city dock. Smaller hotels and boardinghouses sprang up almost overnight. The Carson brothers opened their Pioneer Store. Smith and Bates ran the Gem Restaurant. Fred Malzahn opened a hardware and dry goods store. Tailors, shoemakers, and musicians moved into the town. Saloons and a brisk nightlife kept Bemidji in the news until federal agent W.E. "Pussyfoot" Johnson and his deputies began to close the saloons in 1909 in an attempt to make it a more respectable place to live.

Professional men saw that the town would need bankers, doctors, attorneys, and other services, and seized the opportunity to settle in a town that was not only suited to the logging operations, but also situated on beautiful Lake Bemidji, offering the promise of a tourist destination as well. Willis F. Street was a prominent attorney and city leader. He and county commissioner Frank Dudley were credited with securing the county seat for Bemidji. Charles Scrutchin was a prominent black attorney who became known especially for his work in securing the release of Jim Godette.

Since its infancy, Bemidji was a popular destination for folks from North Dakota, Iowa, and Chicago. The Birchmont Hotel, small resorts, and the cottages of Grand Forks Bay drew large numbers of visitors and summer residents each year. The Markham Hotel, built in 1899, was also known for its quality and high standards. Fishing and sports for all seasons drew many people to this beautiful community. One of the most famous summer residents was Jane Russell, the movie actress, who was born in Bemidji in 1921.

Concern for the quality of the lakeshore emerged early in Bemidji politics. Editorials urged residents to take care of the lake and to make it attractive to other residents and visitors. Bemidji had 11 parks and established a park commission in 1917 to oversee this aspect of the city. Diamond Point Park and Library Park were both early recreation areas and continue to be so today, hosting many events and adding to the quality of life of the town residents. Diamond Point Zoo was a popular destination for nearly 30 years, housing many species of animals, including fox, deer, and moose.

Paul Bunyan and Babe the Blue Ox were introduced to the public in 1937. The popularity of these two statues grew, and they were placed permanently on the shore of Lake Bemidji in 1939. Kodak claimed that the statues of Paul Bunyan and Babe were the second-most photographed tourist attraction in the United States. In 1988, the statue of Paul Bunyan was listed in the National Registry of Historic Places. Bemidji's Paul Bunyan Winter Carnival, and later the Paul Bunyan Water Carnivals, drew thousands to its entertainment venues.

The Sisters of St. Benedict leased the second floor of the Nangle Building in 1897 and equipped it as a temporary hospital, but after only a few months, they found that it was much too small. They purchased land along Lake Boulevard and opened the first wing of St. Anthony Hospital in 1899. A second wing was added in 1900. The hospital was known as a Lumberjack hospital because of the hospital insurance tickets, which they sold in the lumber camps. They cared for men who were injured in logging accidents and those who suffered from pneumonia, frostbite, typhoid, diphtheria, and smallpox, and they also quickly began to provide services to a wide number of patients who came into Bemidji via the railroad for medical care. As the railroad extended its lines north, south, east, and west, it became more important than ever as a center for medical care. Dr. J.P. Omich opened the first drugstore in Bemidji, in the Pioneer Block, in 1896.

Situated as it was in the midst of the pine belt, near the highest altitude in the Northwest, Bemidji was especially appealing to those afflicted with pulmonary diseases. John Dailey was one of those businessmen, who built a small hotel and restaurant but died of consumption on April 2, 1900. Lake Julia Sanatorium opened as a place of treatment for this disease in 1916. Tams Bixby saw the possibilities of developing Bemidji into a summer and health resort destination.

Numerous buildings and roads deteriorated during the Great Depression, and the town was the beneficiary of many projects under the federal work relief programs. Bemidji's leaders recognized the opportunities not only to offer employment to its citizens, but also to address many needs within the town. As one drives through the town today, there are many buildings and much work that was accomplished from 1933 to 1941 under these programs.

Many of Bemidji's earliest citizens were Civil War veterans. They formed a post and hosted the Park Region Convention of the Grand Army of the Republic (GAR) in 1903. Company K, 3rd Regiment, Minnesota National Guard, was formed in 1908. The naval militia was mustered in on June 14, 1915. Bemidji men such as Ralph Gracie and Charles Van Masoner volunteered for military service even before the first draft in 1917. Bemidji's military commitment has been strong, as evidenced by its large number of veterans and active American Legion and Veterans of Foreign Wars organizations.

Bemidji continues to thrive and grow. The addition of the Bemidji Normal School and its growth into Bemidji State University has drawn many students from the Midwest to its campus. Over the years, the town has been used by the military, by airplane manufacturers, and by the Ford Company as a cold-weather testing site. Bemidji is also known nationally for its challenging winter conditions. Ice fishing, cross-country and downhill skiing, and curling all make it a winter destination. It still benefits from its location among the northern lakes, its fine transportation system, a thriving airport, and a supportive population.

One

CHIEF BEMIDJI

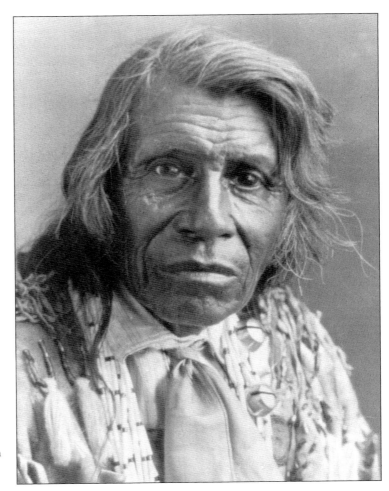

Saddened by his wife's death, Shay-now-ish-kung moved with his family and all his possessions to the south shore of Lake Bemidji in 1883. He was the first to greet the Carson brothers when they arrived to establish a trading post in 1888. He was reputed to be very soft-spoken and friendly to all. In times of Indian unrest, settlers like John Steidl trusted him as a friend and protector.

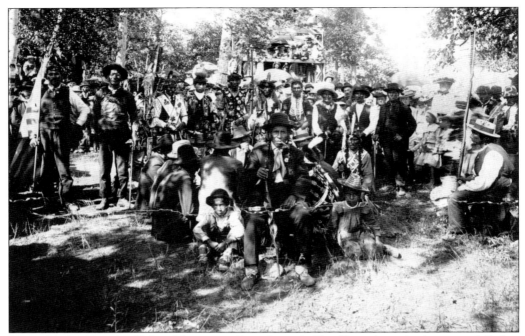

This is likely a Fourth of July celebration in Bemidji, with Chief Bemidji in the foreground. Before there was a bridge across the Mississippi River between Lake Irving and Lake Bemidji, families had to cross between a row of stakes on a sandbar, and water often came up to the wagon box. Chief Bemidji, whose bark home was close to this crossing, would often guide the settlers across.

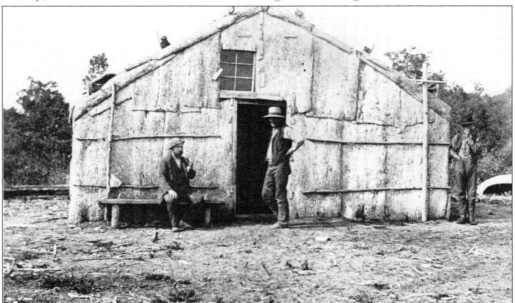

Shay-now-ish-kung lived in this bark house on the east side of the Mississippi River between Lake Bemidji and Lake Irving. He traded moose meat in exchange for enough lumber for the flooring, some of the first lumber sawed and sold in Bemidji. The frame of his home was permanent; the elm bark was replaced as needed. This photograph was taken on August 12, 1894.

Chief Bemidji died on April 19, 1904. He had a handsome black casket trimmed with silver, and many friends sent flowers. All flags in town were flown at half-mast and the businesses closed for the funeral at city hall. Rev. J.F. McLeod stood in the balcony and preached the funeral sermon. A huge crowd followed the horse-drawn hearse up Irvine Avenue to the Greenwood Cemetery.

The first statue of Chief Bemidji was carved out of boards nailed together by a Danish harness maker named Gustav Hinsch in 1898. Also a naturalist and painter, Hinsch waited for a visit from Chief Bemidji and then sketched him as he visited at the Carson trading post. The original statue, seen here behind Maria Lindman about 1910, was moved around but finally placed in Library Park in 1927.

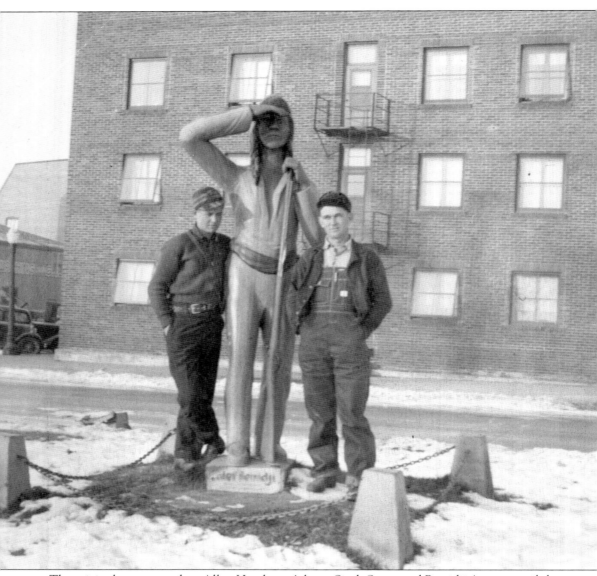

The original statue stood on Allen Henderson's lot at Sixth Street and Bemidji Avenue until the property was sold in 1927. It was then repaired, painted, and set on a permanent cement base. Directly opposite the statue, at 403 Bemidji Avenue, was the Lakeview Hotel, a substantial redbrick structure overlooking Library Park. Morris Kaplan, who opened the Lakeview in July 1942, said that the statue only improved the scenic aspect of the hotel's location. Here, in 1942, Billy Lorentzen (left) and a friend pose with the statue, with the Lakeview Hotel in the background. When the first statue became very worn, a new figure was carved by Erick Boe under the auspices of the Izaak Walton league. This new figure was set in place on July 4, 1952. The original statue is housed at the Beltrami County History Center. The hotel burned in a spectacular fire on June 15, 1964, but the new statue still stands in Library Park. The chief is portrayed with his hand shielding his eyes from the sun, looking across Lake Bemidji to the outlet of the Mississippi River.

Two

NATIONAL REGISTER OF HISTORIC PLACES

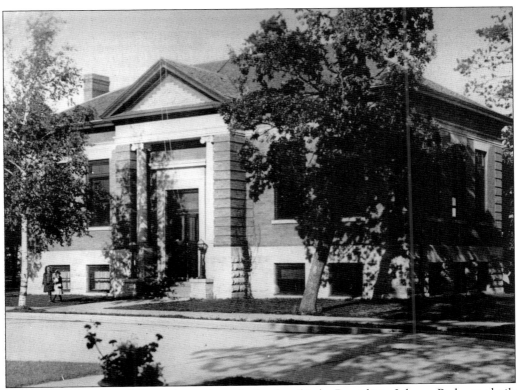

The Bemidji Carnegie Library, located on the banks of Lake Bemidji in Library Park, was built in 1909. It opened on May 10, 1910. It provided service to the general public and to hospital patients and nursing homes, and it became a war information center during World War II. Various authors spoke at the library, including Sinclair Lewis, who encouraged patrons to read books by Minnesota authors.

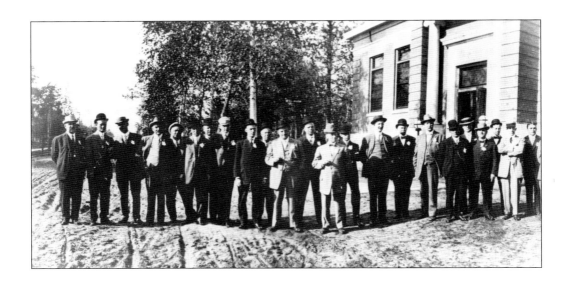

The Carnegie Library (below) was formally accepted on behalf of the library board on March 11, 1910, and the town's businessmen turned out for a group photograph (above). Originally, the architect's plans included a porch on either side of the building overlooking the lake. Carnegie thought the porches were superfluous, and the plans were dropped in order to keep the building costs within the amount of his donation. It was used as a public library from 1910 to 1961. Improvement projects in the 1950s widened Bemidji Avenue in front of the library, increasing traffic and making it more hazardous to cross the street. The Carnegie Library was recognized as a historic property and placed in the National Register of Historic Places on November 25, 1980.

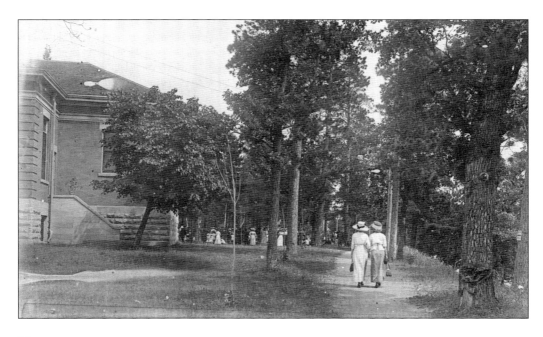

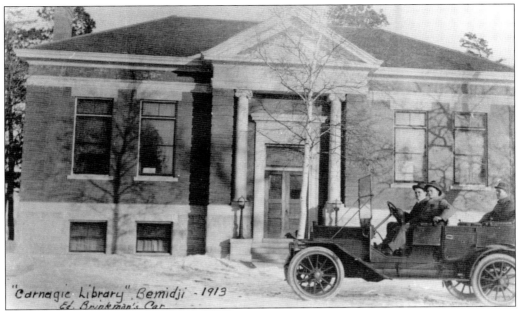

"Carnegie Library" Bemidji - 1913
Ed. Brinkman's Car

In the early days, the library (above) offered many services to the community besides books. One of the most important was when the old high school building burned down on January 16, 1921. Kathryn McGregor Battles (below), who served as the librarian from 1919 to 1921, taught some high school classes in part of the library after the fire. The building itself was an elegant one, with reading rooms to either side of the main desk. Woodwork throughout the main floor was varnished oak, and there was a fireplace in one of the reading rooms. During World War II, the Red Cross sewing room was open every day from 1:30 p.m. to 5:00 p.m., and anyone interested in sewing for the Red Cross was urged to help out. Children later came to the reading room for story time.

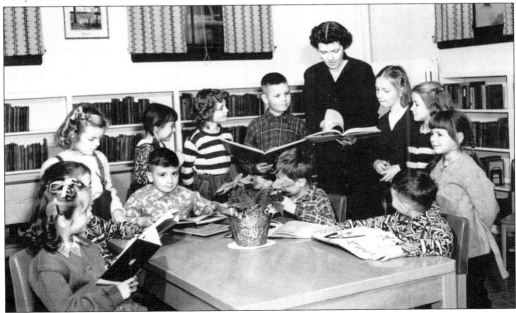

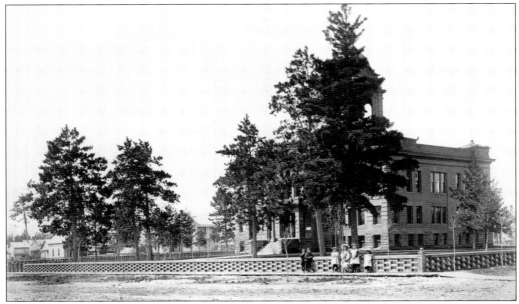

The Beltrami County Courthouse was built in 1902 at 619 Beltrami Avenue. It was designed by Kinney and Detweiler of Minneapolis-Saint Paul and was ready for occupancy on January 1, 1903. One of the most striking aspects of the building is the rotunda. The building had an elegant council chamber, an office for the register of deeds, and an office for the superintendent of schools. The courtroom was up a double flight of stairs. The space behind the three round windows in the center of the building was originally used as the grand jury room. Above the dome is a statue representing Blind Justice. The open area was used as an observation point by members of the Ground Observer Corps during the Cold War. It was placed in the National Register of Historic Places on May 26, 1988.

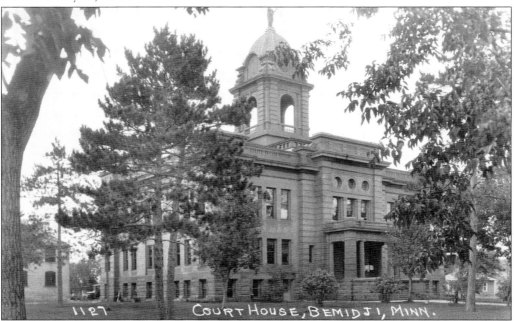

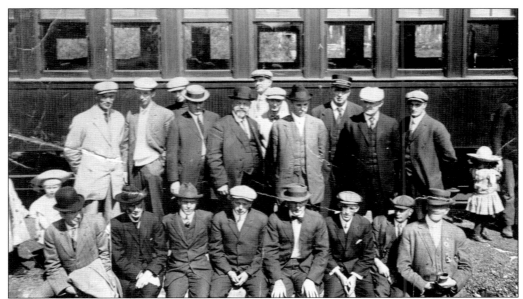

James J. Hill made a visit in a special train car to Bemidji on April 24, 1912, where he was met by a delegation of Commercial Club members (above) who had automobiles waiting to take their distinguished guest for a spin. Despite his age, Hill (below, right) was full of vigor and clad in a blue business suit, a broad-rimmed black hat, and a spring coat, and he was eager for his trip around the area. He inspected the Schroeder farm and then attended a dinner in his honor at the Markham Hotel. Following the dinner, he gave a talk at the armory, where he publicly announced that Bemidji would have a new passenger station as well as a new roundhouse. He returned for the dedication on January 16, 1913, and was warmly welcomed by the citizenry and the businessmen.

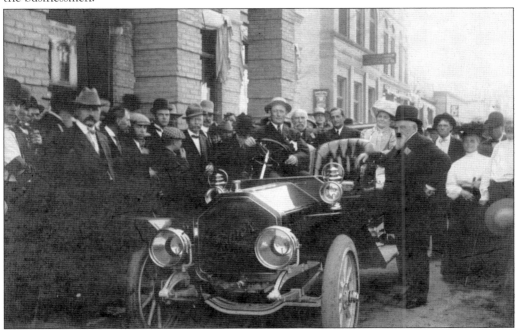

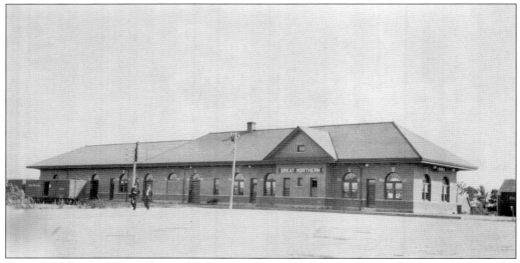

James J. Hill was personally involved in the design of the new Great Northern depot at the south end of Minnesota Avenue. It was the last of Hill's major northern Minnesota depots and, as such, it was placed in the National Register of Historic Places on May 26, 1988. It currently houses the Beltrami County History Center. This photograph shows the new concrete paving done in 1916.

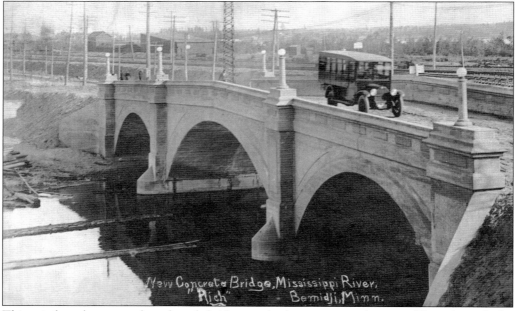

This reinforced-concrete barrel vault bridge was built to connect the city of Bemidji with the village of Nymore in 1916. It carried Route 2 over the Mississippi River channel between the city's two major lakes, Lake Bemidji and Lake Irving. The photograph shows one of the first city buses crossing the Nymore Bridge, which was placed in the National Register on November 6, 1989.

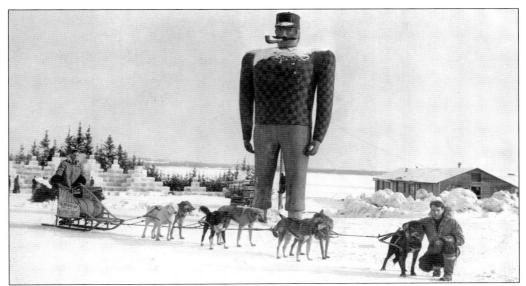

Dogsled racing was part of the Paul Bunyan Winter Carnival in January 1938. The Alaskan Derby course on Lake Bemidji was more than 10 miles long. Eddie Barbeau, Kay Barbeau, Nick Nickeron, and Harold Parker were a few of the more popular entries. Each team, with seven dogs, participated in three heats.

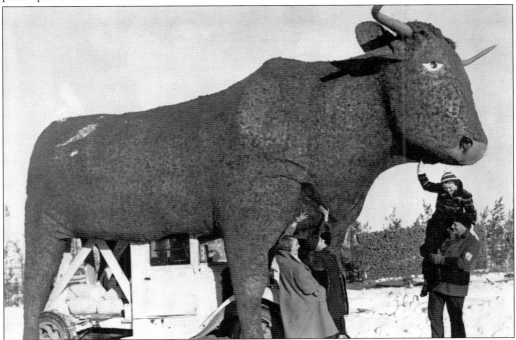

Babe, constructed of blue papier-mâché-like canvas that was placed over an International Truck, first led the Winter Carnival parade in 1937. Exhaust from the truck was hosed to Babe's nostrils to simulate the steamy breaths common on northern Minnesota's coldest days. By May 1937, Babe was at Diamond Point Park and in dire need of repairs. Dan McLaughlin and others raised funds to save the Babe.

Delette Coy, the State of Minnesota carnival queen, led the St. Paul Carnival Club, a group of 40 girls who worked in St. Paul, to Bemidji on Saturday, January 15, 1938, to take part in the Paul Bunyan Winter Carnival. The marching unit participated in Bemidji's parade to promote the upcoming St. Paul Winter Carnival. All were bedecked in uniforms specially made for the carnival.

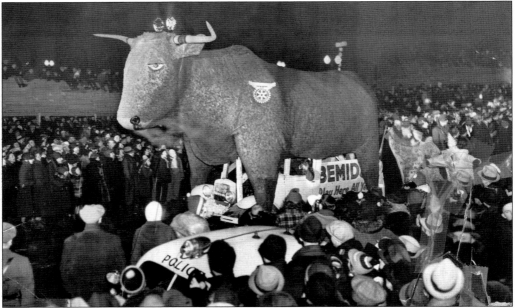

Babe visited St. Paul for the Winter Carnival in 1938. A 14-foot-high blue ox on top of a 1.5-ton International truck with exhaust flowing from its nostrils must have been quite a sight. Babe's eyes, made from taillights, glowed red in the iciest sunlight. Fire marshal Pete Johnson was the designated bullwhacker and accompanied Babe to all parades.

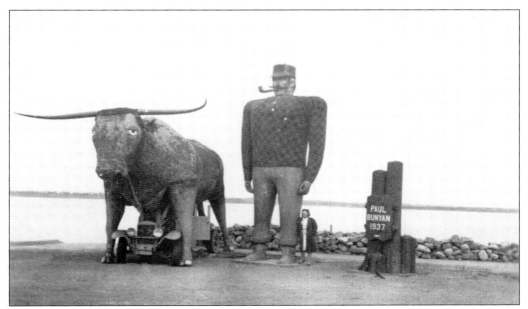

In 1939, Babe the Blue Ox was placed next to Paul Bunyan, and Minnesota's first and best-known example of a roadside colossus was born. They are two of the most photographed statues in the United States. Here, Mabel Hoff Isaacson stands with the two figures in May 1939. Notice the position of the two statues.

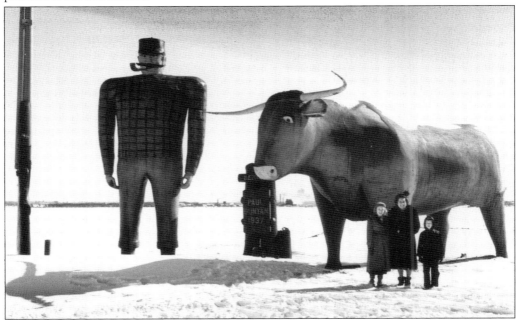

Paul Bunyan and Babe, repositioned and updated, have been photographed in winter and summer. Despite changes in shoreline, weather, and background, the two continue to be popular subjects. Pictured from left to right are Cecelia, Ann, and Phillip Wattles. Paul's shotgun rested beside him for many years. Made of wood, it deteriorated over time and was eventually removed. In 1988, the 18-foot statue of the mythical lumberjack was listed in the National Registry of Historic Places.

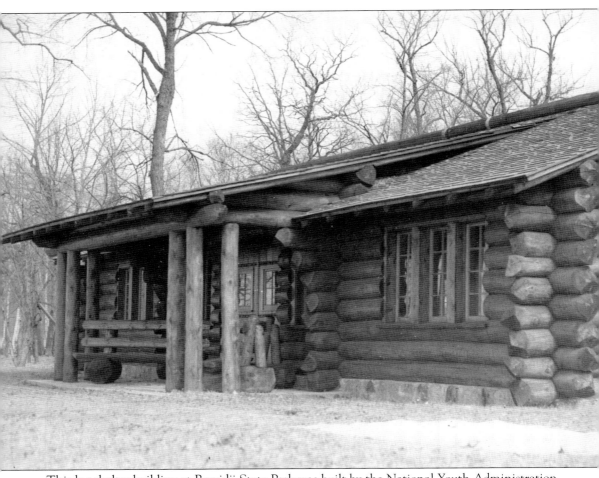

This log shelter building at Bemidji State Park was built by the National Youth Administration (NYA) from 1938 to 1940. The NYA employed young men aged 18 to 25. Ole Sletten was part of a crew that worked on the structure in 1939 and 1940. Separate crews cut the logs in the woods and hauled rocks. After the downed logs were piled up, Sletten and his fellow crewmembers peeled and prepared them for construction. The crew then built the shelter and the rock fireplace within it. At that time, there was no electricity in the park. The logs were not nailed together and no plaster held them together. "They fit together snugly," recalled Sletten. The building was used for many club activities and school outings. During the war years, the park was left without care for want of funds, and as a result, suffered damage from vandalism and neglect. By 1951, Maynard Bjerk, the custodian, had cleaned up the buildings and much of the area. The building was placed in the National Register of Historical Places on October 25, 1989.

Three

WORK RELIEF PROGRAMS

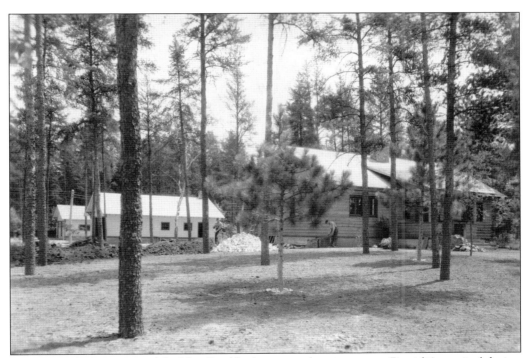

The work relief programs of the New Deal had a tremendous impact on Bemidji's survival during the Great Depression. This photograph, dated August 4, 1936, shows work on one of the projects of the Works Progress Administration (WPA). Workers constructed three buildings, nestled in the pines on the outskirts of Bemidji, for the state's forest rangers: an office, a garage, and a warehouse.

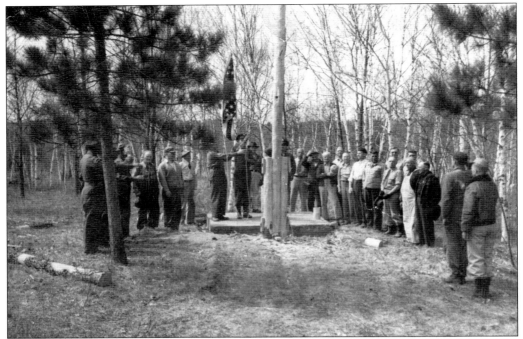

Bemidji men raise the flag at the Civilian Conservation Corps (CCC) camp in Itasca Park. The federal work programs began large-scale recreational development in the park, which was undertaken by two CCC camps and two WPA camps. CCC Camp SP-1 was the first state park CCC camp approved in Minnesota and occupied a site just north of the park beginning on June 27, 1933.

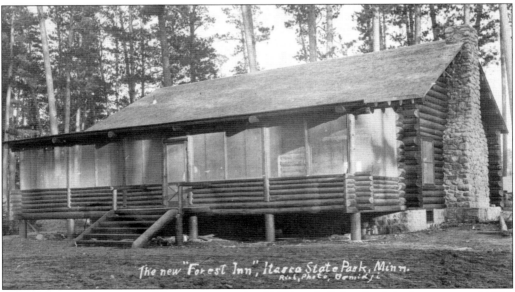

The new "Forest Inn", Itasca State Park, Minn.

One of the camp's more notable projects was the Old Timer's Cabin, built in the summer of 1934. CCC camp SP-1 closed in 1937 and was replaced by CCC camp SP-19. One of their projects, the Forest Inn, is one of the largest buildings in the state park system. Camp SP-19 closed on July 15, 1942, as the last CCC state park camp in the United States.

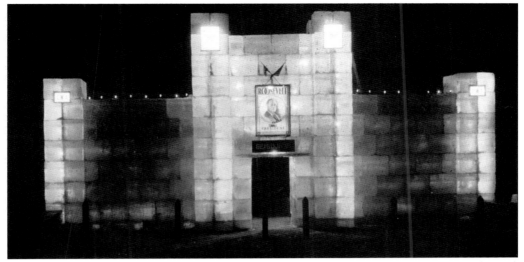

This ice palace on Lake Bemidji was constructed by the Civil Works Administration (CWA) in February 1934 for the Bemidji Winter Carnival. It differed from its predecessors in that it did not depend upon elaborate design and intricate lighting for its effect. The structure, designed by Joe Parenteau, consisted of a simple frame for an illuminated portrait of Pres. Franklin D. Roosevelt.

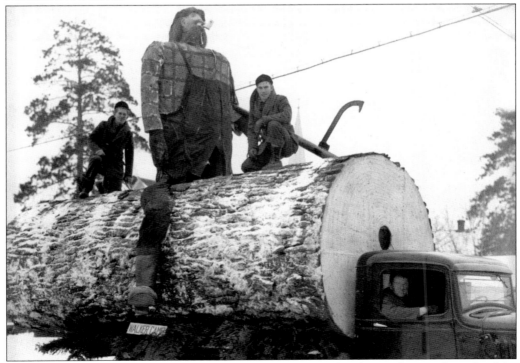

The figure of Paul Bunyan, flanked by two CCC boys, rides on this float in the grand parade of the 1938 Paul Bunyan Winter Carnival. More than 10,000 people lined the downtown streets to watch the mammoth parade, which was nearly a mile in length and included 11 companies of CCC boys. Joe Johnson is driving, and on the log are Walter Leonard (left) and Arthur Shank (right).

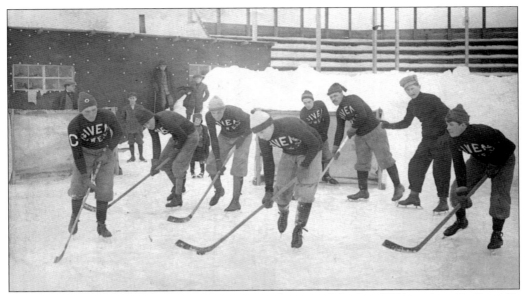

In the summer of 1935, a sports arena was approved as one of the first WPA projects for Bemidji. The arena consisted of a skating and hockey area along with the Curling Club. Members sold $10 memberships and contributed $2,000 towards the construction of the rink. The first Paul Bunyan Bonspiel was held in January 1937, with 48 entries from Minnesota and Canada. The arena was on the old high school property on America Avenue. The northern section of the roof caved in on January 4, 1949, and the skating rink became an open-air rink. The hockey team (above) was sponsored by Given Hardware. The interior of the curling rink is seen below, with the glass windows that separated the rinks from the warming area. The building was taken down in 1967 and replaced by Northland Apartments.

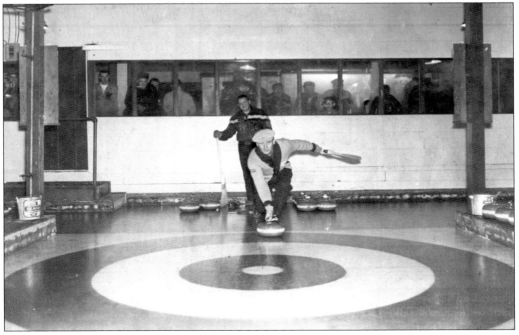

The Paul Bunyan House was completed in 1934 under the Civil Works Administration (CWA). As no new building was allowed under the CWA authority, it had to be considered an addition to the warming house used by the skaters on Lake Bemidji. The park commission insisted that it be built to leave the view of the lake unobstructed from the corner of Beltrami Avenue and Third Street.

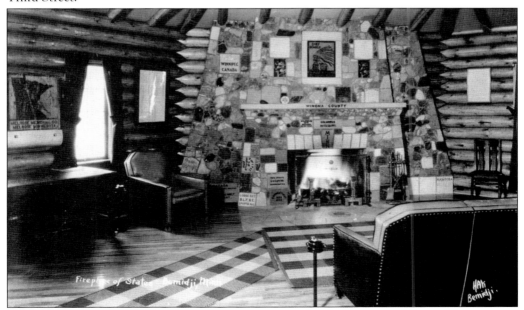

Harry Roese wrote hundreds of letters requesting stones for the Fireplace of States. The response was so great that they had to put wings on the fireplace to use them all. The Bunyan House was the headquarters of the Bemidji Civic and Commerce Association. It was torn down in 1994. The fireplace was taken apart and reassembled for the new Chamber of Commerce Information Building on the lakefront.

Albert Treichel was the caretaker of Library Park for more than 20 years. With the advent of the WPA, a crew of men was immediately assigned the tasks of landscaping, seeding new grass, and erecting walks and boulevards throughout this park. Many loads of sand, gravel, and black dirt were hauled and dumped over the bank to create a grassy slope reaching from the bank's top to the shoreline.

This photograph, dated August 4, 1936, shows part of the Bemidji lakeshore, where the WPA did considerable riprapping and cleaning beginning in 1934. The deadheads, moss, and black squelchy mud that lay on the lake bottom from the armory to the point was removed. Sand was hauled in to create a beach and provide a sandy lake bottom stretching out 70 feet from the shore.

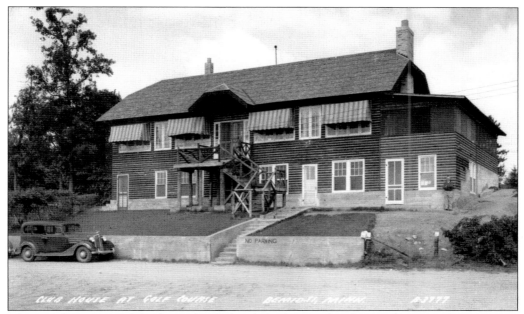

The Bemidji Country Club is located at the head of Lake Bemidji. The Crookston Lumber Company loaned equipment and horses to clear the land. Jim Black, a well-known Bemidji lumberman, supervised about 30 lumberjacks, who did the labor. Gus Stahl, an early greenskeeper, lived with his family in a house on the hill where the clubhouse now stands. When Stahl left, George Figel held that position for 33 years.

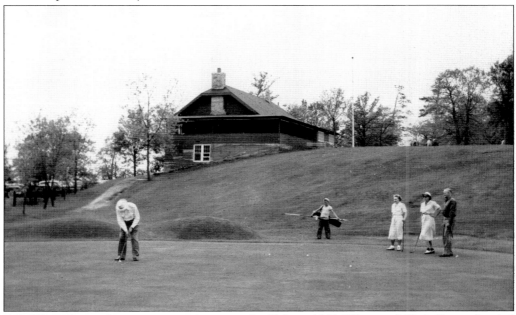

A.P. White first took an interest in the game of golf about 1915. White and Clyde Bacon decided to try for a golf course in Bemidji. They finally managed to organize a club by 1918. In the early days, there was no clubhouse, so a green barn-like structure near the 18th green was used. The golfers finally got a new clubhouse as part of a WPA project.

WPA men built a cinder path along Lake Boulevard from Library Park to the State Teachers College. They also constructed a retaining wall of native rocks to preserve the bank from further erosion. Stone steps and concrete flumes were erected at intervals, and a steel cable was installed for safety along the top of the bank. Many remember the Indian Trail and playing in this area near the Lutheran hospital.

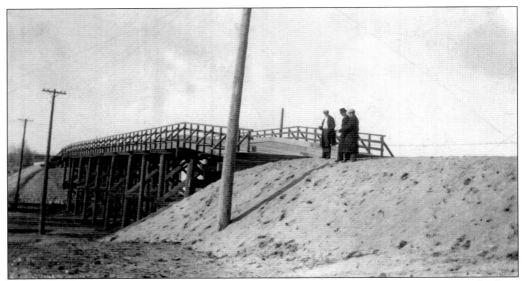

The old viaduct that crossed the Great Northern & Soo tracks on Irvine Avenue was built in 1910. By 1935, it was in such poor condition that it should have been condemned. Construction of a new viaduct was one of the earliest WPA projects undertaken in Bemidji. Many recall the rumbling sound of the cars crossing over the wooden viaduct and the whistle of the trains passing underneath.

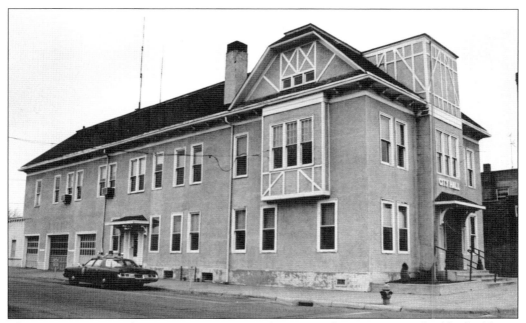

The WPA inaugurated an extensive program of repairs and construction of public buildings. In Bemidji, the city hall, jail, and firehouse were in urgent need of repair, as the hall had been constructed in 1899 and the jail in 1900. The balcony, bell tower, and dormer windows facing Minnesota Avenue were removed, and the exterior was covered with stucco. This building was demolished in March 1981.

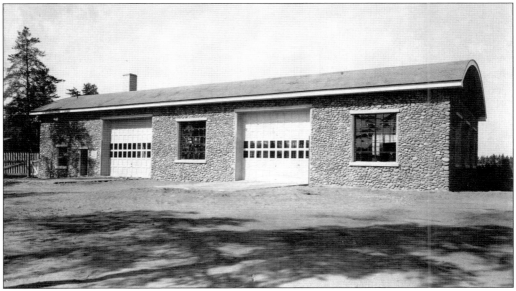

The WPA was essentially a local program. Each community got what its officials wanted and requested. One of the most outstanding projects in Beltrami County was the county highway garage, constructed of monolithic concrete and faced with fieldstone. This spacious building replaced an old, wooden structure. The building was erected during the winter months of 1935–1936 and provided employment for many unskilled laborers in the city.

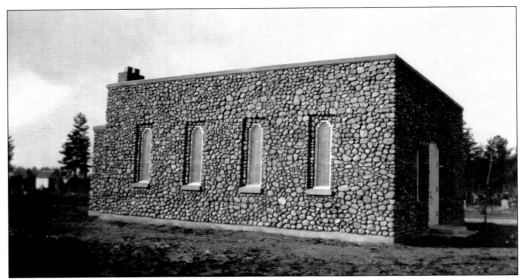

Sam Kudish, the WPA administrator, presented a plaque to Bemidji mayor F.G. Troppman, formally turning over the Greenwood Cemetery chapel to the city of Bemidji in January 1937. The meeting and presentation was held in the Peacock Room of the Rex Café and attended by more than 50 officials from city, district, and state offices. The building remains today, although offices have been added to the side.

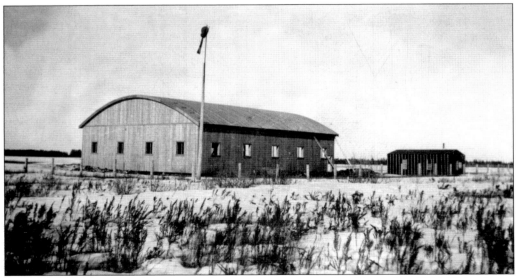

Funds for the hangar at the municipal airport were approved in December 1936. This airport operated until the current airport was built in 1946. A special ceremony was held on Sunday, August 29, 1937, and Victor Christgau, the state WPA administrator, dedicated the new hangar and turned it over to the city at the National Aeronautical Association Convention banquet, held in the Birchmont Hotel.

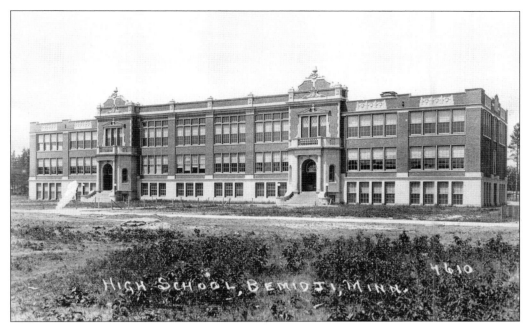

After a disastrous fire on January 16, 1921, Bemidji built a new high school (above) on Fifteenth Street. Classes were held at the Carnegie Library, at Central School, and at other locations throughout the city until the new building was ready for occupancy. It opened on September 14, 1922. In late 1938, Bemidji received a Public Works Administration (PWA) grant to construct a $175,000 auditorium (below). After a spirited meeting by the school board on April 26, 1939, the vote was 4-2 to go ahead with the project. Two members hesitated because the project required a substantial contribution by the school district. This splendid building, with a connecting tunnel to the high school, was ready for the 1940–1941 school year. It hosted musical events, graduation ceremonies, and visits by dignitaries such as Hubert H. Humphrey. It was taken down on July 1, 2008.

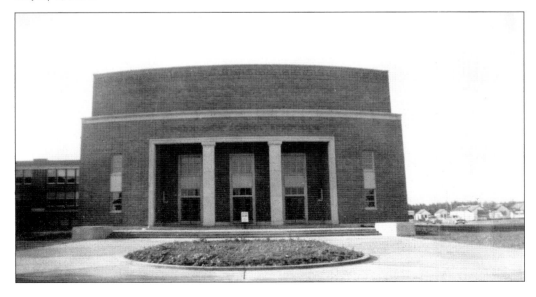

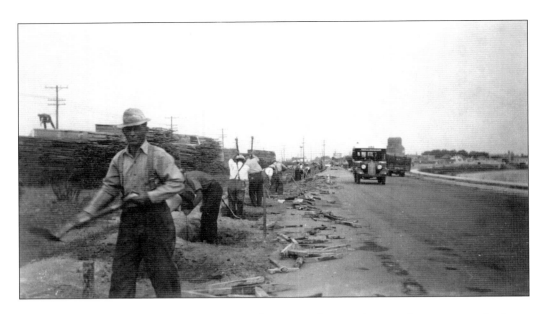

The highway project above was begun in April 1934, employing 44 men to bring in a new highway from Nymore to downtown Bemidji. Workers were also employed by the Civil Works Administration (CWA) to tear down the old mill buildings, formerly owned by the Krueger-Broughton Lumber Co. of Minneapolis, to make room for the new highway. The highway was designed to eliminate dangerous curves and create a beautiful approach to downtown. In the early years of the Depression, these facilities had been neglected because of inadequate funds. Roads were often in poor condition, streets had become rutted and worn, and many bridges were in serious need of repair. The new roadway (below) was opened to traffic on October 31, 1936, and was vaguely referred to as South Shore Drive until it was officially named Midway Drive in 1944.

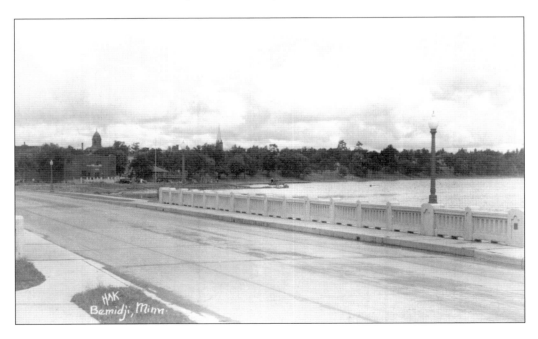

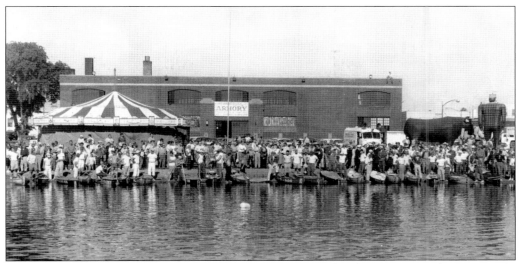

When the new armory was built in 1921, the main entrance faced west on Bemidji Avenue. As the highway passed in front of the entrance, this became a serious hazard for pedestrians. With the help of the WPA, extensive repairs were made to the armory, including a new entrance facing east to Lake Bemidji.

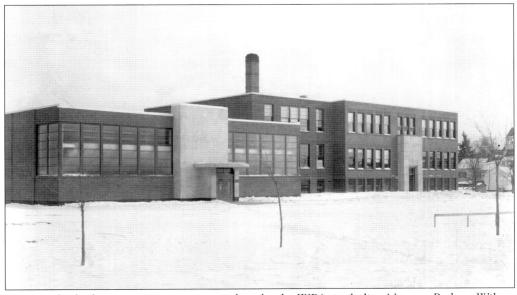

Nymore also had numerous improvements done by the WPA, including Nymore Park, at Wilson Avenue and Fifth Street. This photograph of the work at Lincoln Elementary on Fourth Street was taken by Hakkerup Studio on December 9, 1938. Lincoln School celebrated its 100th birthday in the 2003–2004 school year with a variety show and the publication of a school history.

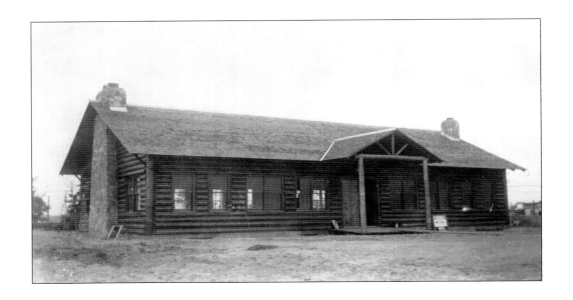

Work on the American Legion clubhouse project, sponsored by the Ralph Gracie post, got underway on January 20, 1936. The clubhouse, at 300 Midway Drive, was on the east bank of the Mississippi River between the old and new highway entrances. The riverbank was filled in for a considerable distance to the level of the new highway. The result was a log recreation building that provided a meeting place for various civic organizations. An Armistice Day dinner was scheduled there on November 11, 1940, but a blizzard kept most people away. After the Ralph Gracie post moved into its new location at 219½ Minnesota Avenue, the building was occupied by the Bemidji Candy Company and then the Wildlife Museum. Alice Bowers was a cashier at the museum.

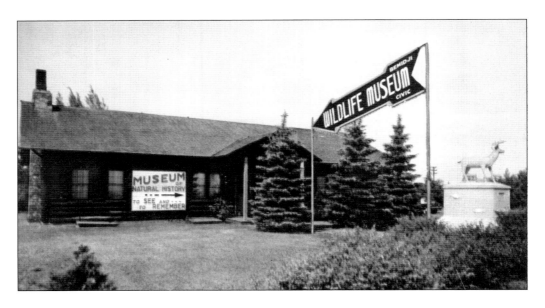

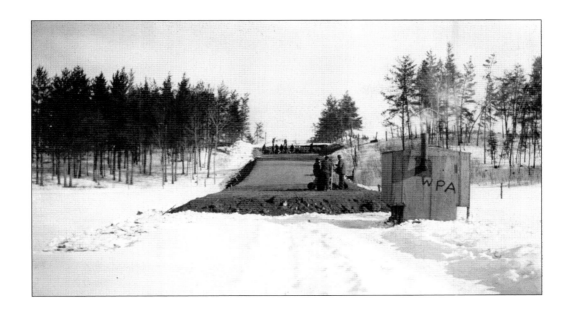

The farm-to-market road aspect of the WPA program, which comprised about one-third of all the roadwork undertaken in 1936, involved a variety of improvements to the dirt roads of the country. Sometimes this roadwork consisted merely of filling in low spots that rendered roads impassable in rainy weather. In other instances, projects called for grading and leveling to remove ruts and low places and ensure better drainage. Sometimes, the work was much more extensive. William Hines, who settled south of Blackduck Lake, recalled early experiences with the WPA project: "I well remember the stage from Bemidji into this country and the rough roads it came over. The driver would not let you ride unless you would let him strap you to the wagon so you would not be bumped out."

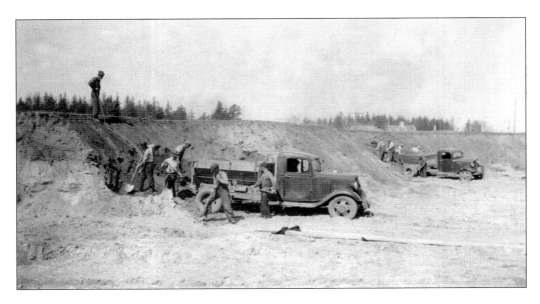

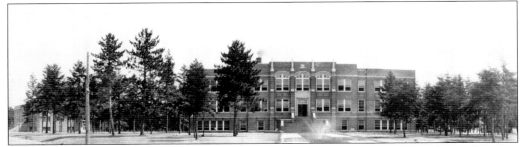

Bemidji residents were elated when they learned that Bemidji had been chosen as the site for a new normal school. An impromptu parade was put together, and the city celebrated. The cornerstone for the main building was laid in 1918. The college accepted its first students on June 23, 1919. This 1939 Hakkerup Studio photograph shows Deputy Hall, which was built in 1926.

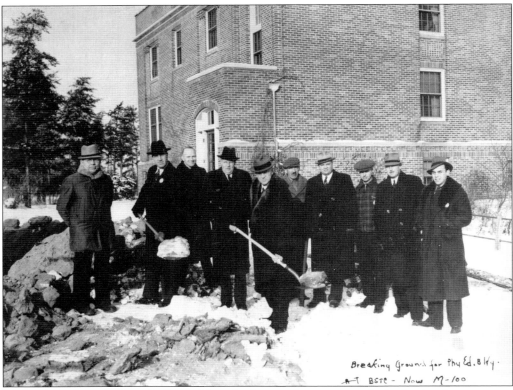

Breaking Ground for Phy Ed. Bldy.
At BSTC - Now M-100

In the 1930s, Bemidji State College athletes had to use the armory or the high school gymnasium. On April 23, 1937, officials received approval for a large building to carry on their athletic program, but it was not until January 1, 1938, that they turned the first shovel of dirt at the ground-breaking for the addition, known as Memorial Hall. The new college gym was dedicated on February 10, 1940.

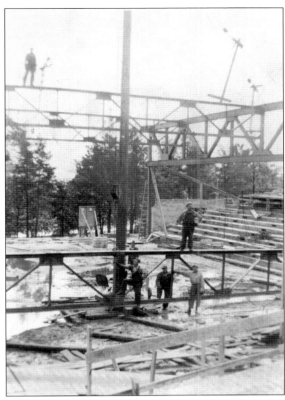

When federal funds were designated for Bemidji State in 1937, a new football field was part of the athletic facilities building plan. Combining funds from the state relief program with the WPA funds, work on the athletic fields began in 1940 and was completed the next year, at a total cost of $60,000. The cement bleachers on each side of the football field could hold approximately 4,000 people. When completed, the college had a new football field and bleachers, but it also boasted a new practice field, a softball diamond, a soccer field, a new 440-yard track, a concrete court for handball and basketball, and four concrete tennis courts. Although the wind off the lake was always a bit brisk in the fall, it was a popular venue for community and high school sports as well.

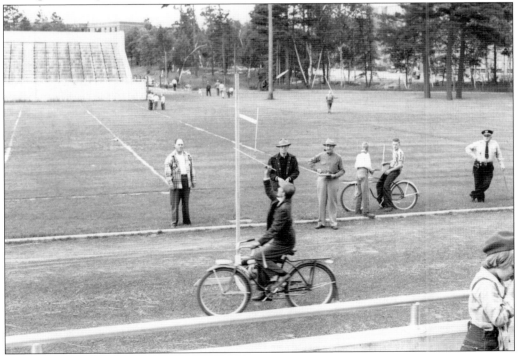

A substantial number of women were put to work under the WPA. They were considered unemployed heads of household for a variety of reasons, including abandonment or because of a husband's death or disability. Many men also sought jobs far from home, and women depended on work with the WPA programs as their only source of family income. Although there were a few professional jobs open to women, the largest percentage entered the workforce in sewing projects of some sort. Most were still sewing by hand, but they were trained to use sewing machines. Once they became skilled with the machines, they were put to work making clothing, bedding, and supplies for hospitals and orphanages. The local sewing project was housed in several places, but the best known was in a new building put up in 1938 on the northeast corner of Fifth Street and Irvine Avenue. This building was leased to Munsingwear from 1943 to 1952. It was sold in 1952 to the Bethel Lutheran Church and was home to that congregation until 2000.

Four

PARKS AND RECREATION

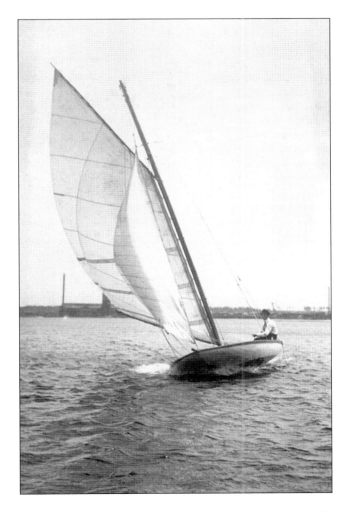

Bemidji has always been a popular destination for summer fun. Lake Bemidji provides an opportunity for sailing and other water recreation. Lake Irving was known for its fishing and was connected to Lake Bemidji by the Mississippi River outlet. Bemidji's park board established 11 parks. An important early business, the Crookston Lumber Company, is in the background on the far shore.

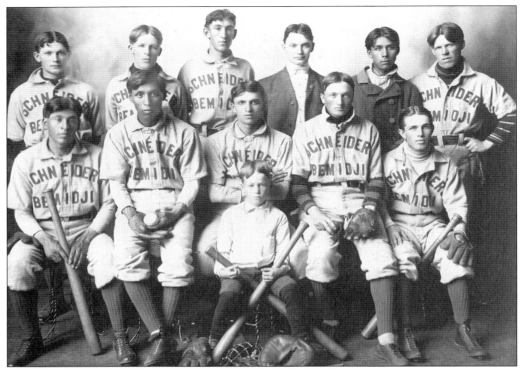

Rowe McCamus, a Bemidji printer, pitched and played shortstop for the Bemidji town baseball team (seen here) and for other sponsored teams, including the Schneider Brothers team. Frank Finn, who played right field, is also in this photograph. Many games were played at the fairgrounds on the north side of town, but in 1906, the town secured use of the property on Block I for a first-class baseball park.

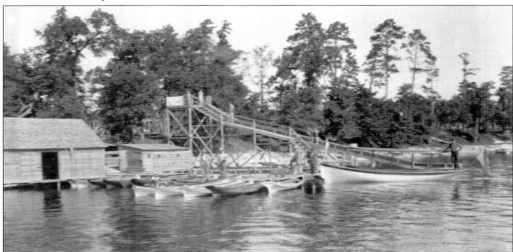

The water toboggan slide at Birchmont, seen here, was constructed in June 1922. It consisted of a slide with 12 toboggans, each equipped with rubber-tired wheels. These four-foot toboggans shot down the 60-foot incline from a 16-foot tower. No other summer resort in this section of the state had one, and it was very popular.

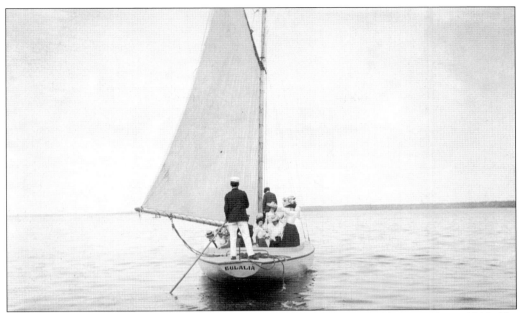

Capt. W.B. "Mac" MacLachlan first started carrying passengers on Lake Bemidji in 1898. His first boat was a small racing yacht, the *Eulalia*. In 1900, he sold season tickets for $5 each. The ticket entitled the holder to ride on the *Eulalia* any time they went out. He built his second boat, the *North Star*, in 1906.

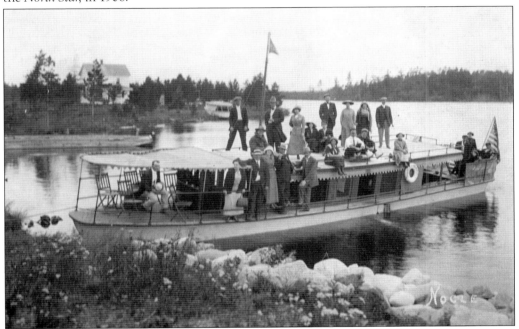

MacLachlan built his pleasure boat *City of Bemidji* in 1912. It was built of oak and could carry 80 passengers. This excursion party is pulled up above the dam on the Mississippi River, seven miles from Lake Bemidji. This boat was totally destroyed on a run near Diamond Point in May 1916. MacLachlan then built a boat called the *Yankee Girl*, which he sold in 1920.

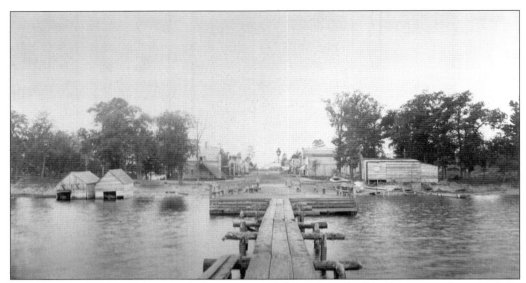

Bemidji valued its waterfront, and this was one of the earliest docks. This rustic photograph by Sprague of Third Street looks west in 1897. The ice took out the first dock in 1898 and it was rebuilt the very next year. In 1897, Remore's Grand Central Hotel; Fred Bjork, shoemaker; and James Brennen's tonsorial parlor were all at the intersection of Third Street and Beltrami Avenue.

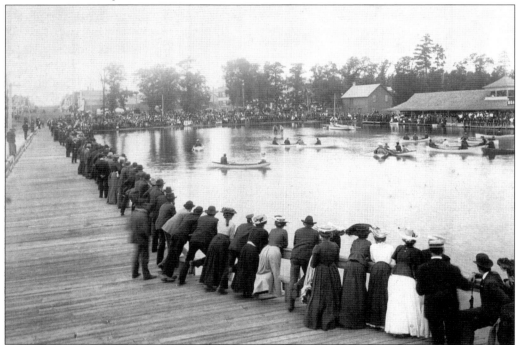

After having no civic celebration of the Fourth of July for three years, Bemidji's Commercial Club voted in favor of a celebration in 1903 and promised a great one. The absence of waterfront entertainment may have been a consequence of the horrible disaster during the 17th of May celebration in 1901, when several people drowned. This 1903 photograph shows a logrolling contest at the city dock.

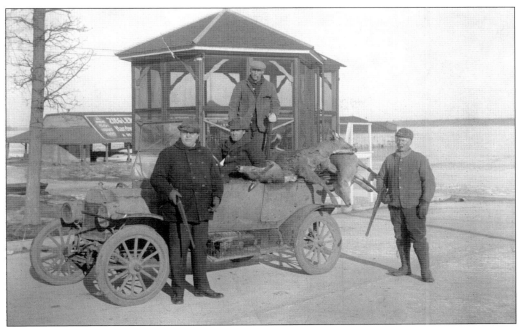

These hunters parked at the foot of Third Street near the bandstand to show off their deer. The bandstand was originally at the end of the dock, but it was later moved here. It was moved again in 1918, to Library Park, after people complained that they could only view concerts from one side unless they got in the mud on the shoreline of the lake.

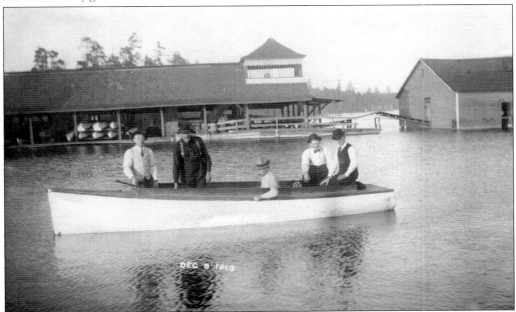

In 1913, an exceptionally warm November and December pushed the boating season into December. Captain MacLachlan twice planned to put his passenger launch, the *City of Bemidji*, up on dry dock for the winter, but the lake showed no signs of freezing. This photograph, taken on December 8, shows men still in shirtsleeves with their boat in open water near the city boathouse.

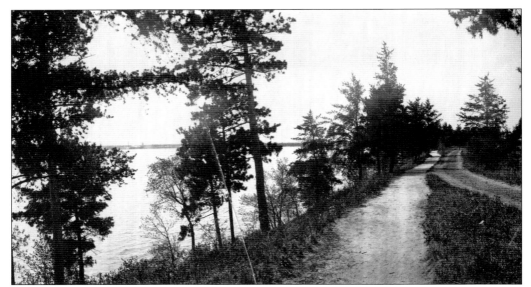

The old Indian trail along the west shore of Lake Bemidji is seen here before the city park was created in 1907. The park eventually included the Carnegie Library and was renamed Library Park. When Henry Stahl, who had operated the city boathouse, sold his property on the west shore of Lake Bemidji between Third and Fourth Streets, this plot also became part of Library Park.

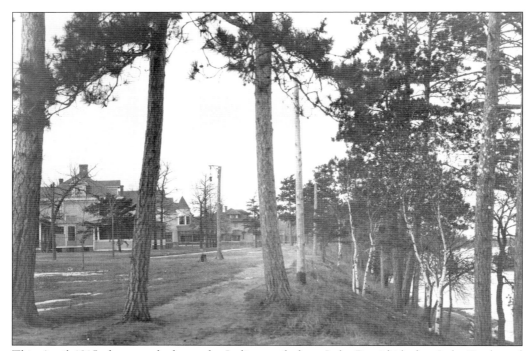

This April 1915 photograph shows the Indian trail along Lake Bemidji before Lake Boulevard was put in. The Einer Johnson house, north of Library Park, is in the foreground, and the Clyde Bacon house, at 621 Lake Boulevard, is about midway down the block. Arthur Wedge later owned Johnson's house, and the Bacon house eventually became St. Mary's Convent.

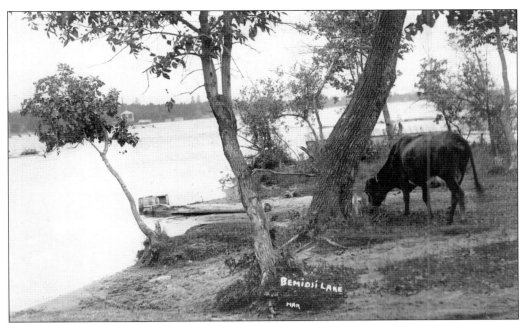

BEMIDJI LAKE

HAH

In 1901, A.M. Greeley, the editor of the *Bemidji Pioneer*, urged the formation of a park commission in order to take some interest in the care of the lakefront (above). He wrote, "To have people who live immediately adjacent to the lake front, turn their cows out to pasture along its borders indicates some need of police surveillance to be effective. Bemidji's lake frontage should be preserved in all its original beauty free of all such hazards."

The park board established a skating rink on the old high school site between America and Irvine Avenues in 1924. A warming house was built, and the rink was under the supervision of George S. Harris, who also gave free instruction every afternoon. The Figure Skating Club became very popular. Here, Lucille Clausen (left) and Arlene Schmunk Abrahamson pose on the ice in 1939.

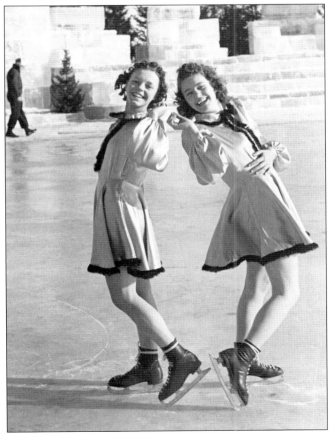

Freeman and Betsey Doud were the first settlers to homestead on the west side of the lake. Doud's claim extended from the edge of the lake westward through the woods and included the Greenwood Cemetery site. He filed on the land on June 30, 1896, and by August, he had erected a small home on the southeastern side of Diamond Point.

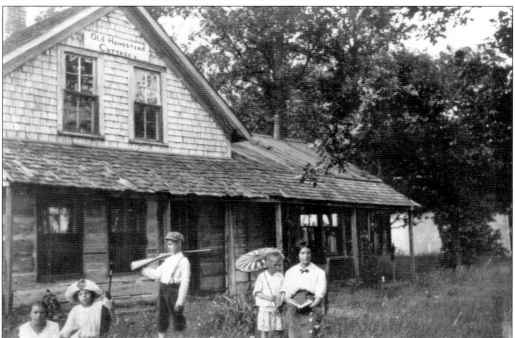

Although they kept their summer home at the lake, the Douds moved into town, to 345 America Avenue, and Freeman lived there until his death in 1909. The Doud home at Diamond Point was converted for use as a cottage. The John Ross family is seen here while vacationing at the Old Homestead Cottage in the park.

Doud sold nearly 160 acres to W.F. Street and A.A. White in the spring of 1903. Doud excluded only a small parcel of property for his summer home and a small lot that he had sold to a Mr. Tozer. Street and White intended to make the property into a resort and build a pavilion if the boatmen could bring people across the water for 10¢ per dock. However, Street was shot and killed on August 6, 1903. As a result, White became the sole owner of most of the Diamond Point property. The spot had become a favored bathing and picnic site. In the spring of 1917, Bemidji's first parks commission was established, and its first acquisition was the neck of land known as Diamond Point. In 1918, P.R. Peterson, the director of the Bemidji City Band, was appointed custodian for the season. He arranged concerts there and, while he received no pay for his services, was also put in charge of bathing and refreshment privileges.

In the 1930s, the park board decided to build additional cabins at Diamond Point to accommodate tourists passing through Bemidji who were unable to find lodging elsewhere. Several resort owners objected. However, the Works Progress Administration (WPA) was in the process of initiating a county-wide cleanup, which included cleaning the logs and debris from Lake Bemidji. This coincided well with the building projects underway at Diamond Point Park.

Under the direction of the WPA, Diamond Point Park was renovated in many ways. The footbridge on the north side of the park was built, land was cleared, roads were built, and riprapping of the shoreline begun. Buildings were repaired and the zoo pens were thoroughly cleaned. Unfortunately, the bathhouse burned down in the late 1940s, and a new one was not built until 1952.

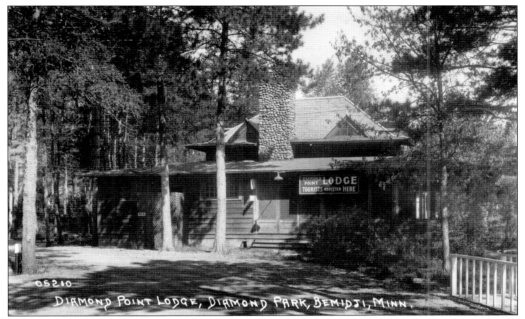

DIAMOND POINT LODGE, DIAMOND PARK, BEMIDJI, MINN.

In 1938, Diamond Point had 14 overnight cabins for the convenience of tourists. Space was also provided for the parking of trailer houses and the pitching of tents. Each summer, an increasing number of tourists used the facilities at Diamond Point. Deep wells provided plenty of clean drinking water. During the summer months, a lifeguard was also in attendance.

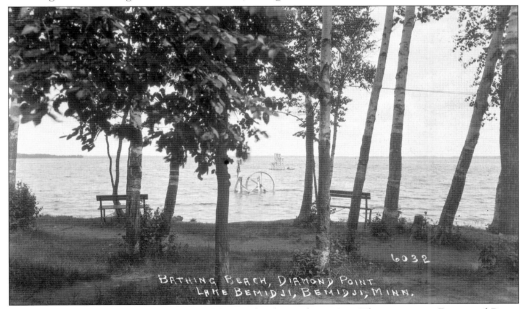

BATHING BEACH, DIAMOND POINT
LAKE BEMIDJI, BEMIDJI, MINN.

Construction was started on a new bathhouse for the park in 1921. The next year, Diamond Point received electricity. By 1924, there was a new bathhouse, dock, and waterwheel in addition to a well, plumbing, and wiring. Swimmers often swam out to the waterwheel to sunbathe before the season was in full swing. The water was shallower than expected, and occasionally, a visitor was hurt when he misjudged the depth of the water.

51

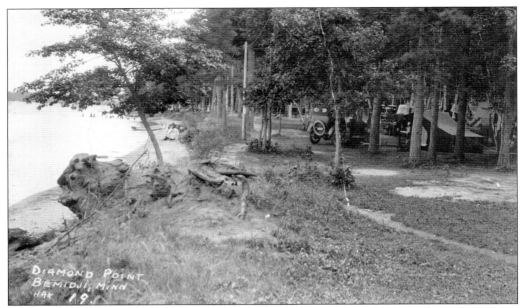

The most popular park in Bemidji's park system was Diamond Point Park, on the original Doud homestead. When Freeman Doud died in 1909, his wife, Betsy, traded her land to the Townsite Company for a house at 600 America Avenue. She died in 1916. The park board purchased the Doud property and the neighboring Tozer claim in October 1917. The Tozer buildings were moved and used for cabins for overnight visitors at the park. Diamond Point was expanded in 1922 when the park board purchased a valuable tract of land between the existing park property and Grand Forks Bay. A.A. White sold 11 acres of prime lakeshore for $5,200 so that the zoo and the park could be expanded.

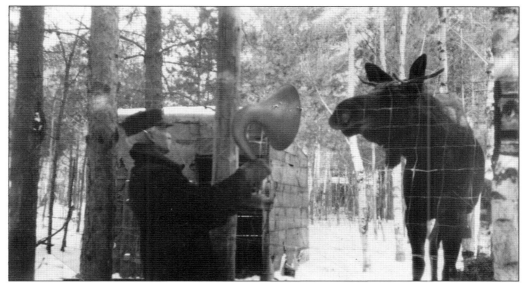

In June 1920, the park board established the beginnings of the Diamond Point Zoo when they secured a yearling deer. This attraction drew huge crowds. Game warden John Cline provided the zoo with most of the animals, including two seven-month-old male black bears, a pair of elk, and two healthy brush wolves. George T. Baker, the superintendent of the park board, made a special trip to Funkley to bring back a doe to keep a lonely buck company. In 1922, two young moose were acquired by the park. The bull moose was fed milk four times a day, and the cow moose received equal attention from Frank Patterson, the park policeman. Patterson supervised the amount of browse that visitors brought to the zoo for the popular moose, the only one in captivity in Minnesota. Patterson is seen above recording the sound of the moose.

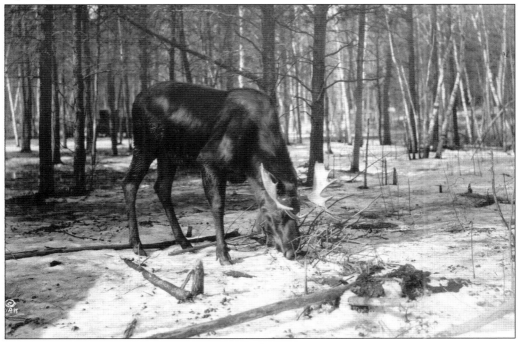

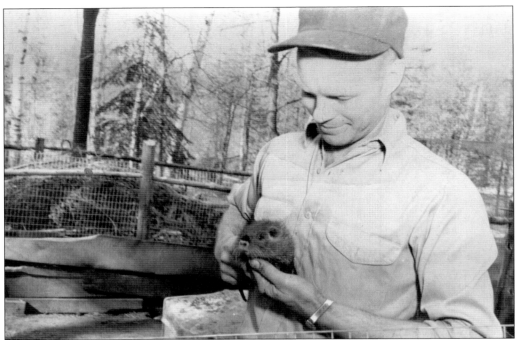

Pete Cameron, who succeeded Patterson as park superintendent, tended animals native to the area, including bears, wolves, coyotes, foxes, porcupines, beavers, and raccoons. Miss Bemidji, a pet fawn, was a big attraction at the Northwest Sportsmen's Show in 1944. A large grazing area was fenced for deer, elk, and eventually a buffalo. Leonard Dickinson donated the buffalo, but it was difficult to keep it fenced, so he was eventually asked to take it back. The park board began to complain in 1939 that it was too expensive to maintain the zoo. The Jaycees tried hard to save the zoo and appealed to the city council, offering to build a new zoo at their own expense if the city would maintain it. Despite their efforts, it was too late, and the zoo was lost. The two male bears went to the zoo in Rochester, and the zoo closed on July 1, 1950.

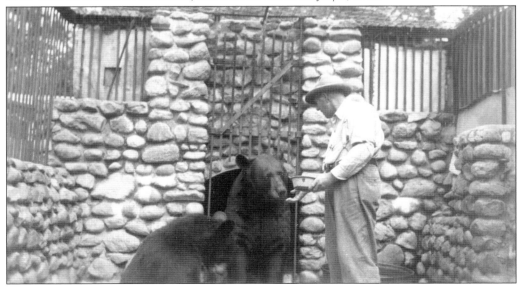

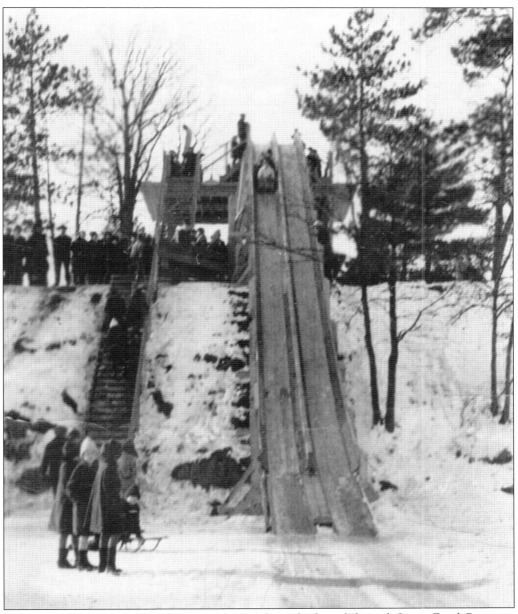

In January 1922, the park board constructed two slides at the foot of Eleventh Street. Frank Patterson of the park board police supervised the slides. A more permanent toboggan slide, sponsored by the American Legion, was built in Library Park in December 1925. Charley Rantz and his crew did the work. The legion sold tickets for $1 each to help with the cost of construction. The park board built a new bandstand in connection with the slide. The lower storage section was 20 feet by 20 feet. Above this, the bandstand was 24 feet by 22 feet. The slide extended from the roof, which was 22 feet above the ground. An outside stairway provided access to the top of the slide, which measured 80 feet in length and had a goodly pitch to the level of the ice on the lake. It had two tracks. Although one report says it was removed after a year or two, video of the 1939 Paul Bunyan Carnival shows what looks like the very same slide.

Lake Bemidji State Park, or Rocky Point, was created by an act of the Minnesota Legislature in 1923. In 1932, the forestry department planted 3,000 white and Norway pines in the part of Bemidji State Park that had been burned over a few years before. The trees were planted as part of the Washington bicentennial and for reforestation of the part of the park where trees did not reproduce themselves. From Rocky Point, there is a spectacular view of the entire lake. The park was dedicated in August 1938 in connection with a Civilian Conservation Corps (CCC) water carnival. It was a favorite camping place for vacationers and provided bathhouses, beaches, drinking water, and numerous stone ovens, tables, and benches throughout the camp area. It was turned over to the state in 1954.

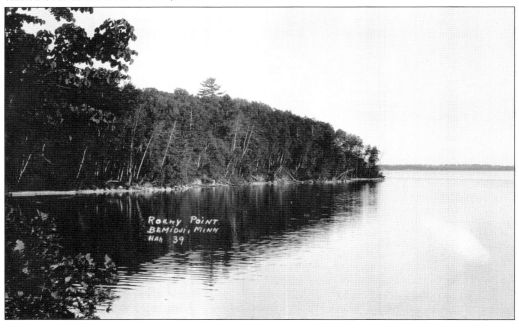

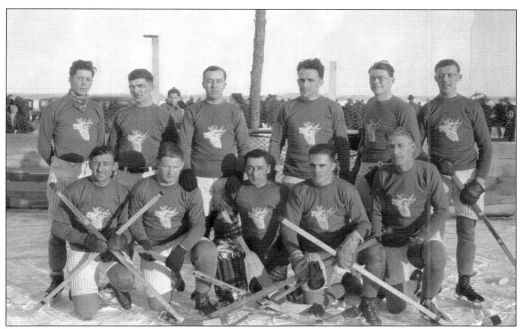

The lake provided recreation in summer and winter. O.G. Olson, a former hockey player, organized a hockey team in 1924. The 1931 Elks hockey team seen here included, from left to right, (first row) William Krause, Norman McDonald, Winthrop Batchelder, John Elwell, and Palmer Berg; (second row) Herb Whiting, Hank Krause, George Van Camp, Jack Sterret, Albert Bennington, and Ray Krause.

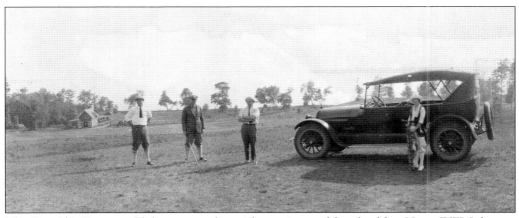

The Bemidji Country Club was popular with tourists and locals alike. Here, E.W. Johnson (center) and his wife, Jessie (far right), enjoy a visit to the golf course. The old clubhouse, a green barnlike structure, is on the left. Willie Dunn was likely the first golf pro at the course. He was from Scotland and was typically Scottish, with the brogue and the tam o'shanter.

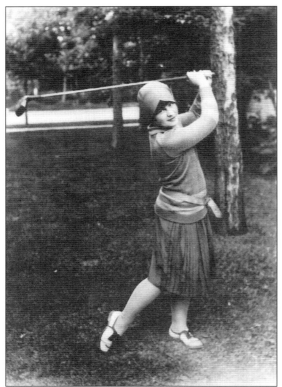

Eleanor Bowser Pfau, seen here at the age of 18 at the country club, was one of the earliest female golfers. After the terrible forest fire at Moose Lake in October 1918, a call went out for relief funds, and a nine-year-old Pfau brought in 69¢. Some other early female golfers were Margaret Lycan, Isabel Baer, Martha Shute, Archer Birdie Richardson, and Donna Lycan Hall.

Many of the players continued to golf at the Bemidji Country Club consistently for many years. These three unidentified locals posed for a photograph to share with their friends. The Bemidji Country Club was in full swing in the 1920s. The annual Birchmont Golf Tournament started in 1924 and continues yet today.

Five

MILITARY

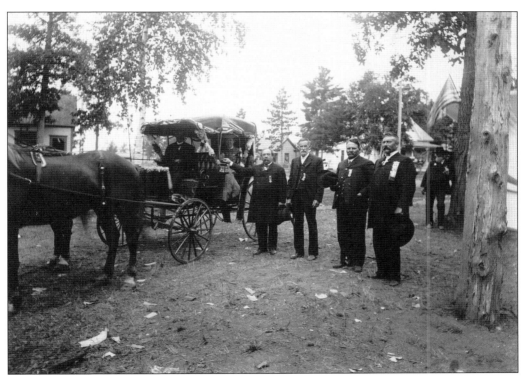

In 1898, Freeman Doud organized the R.H. Carr Post of the Grand Army of the Republic (GAR) following Carr's death in April of that year. Cyrus Smith became the first commander of the post. Here, Gov. Samuel Van Sant (standing, far left) is seen with other veterans at the GAR encampment in Bemidji on July 21–24, 1903.

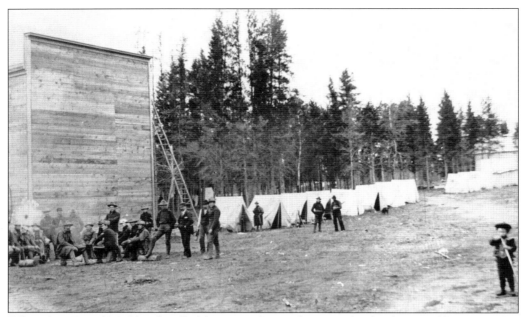

When Gov. David M. Clough called for troops during the Bear Island Indian troubles in October 1898, a detachment of the 14th Minnesota Volunteer Infantry under Col. Charles Johnson was sent to Bemidji. They built their encampment on the west side of Beltrami Avenue between Fourth and Fifth Streets. The building was located right about where the southern half of the Woolworth's was for many years, about one block from the lake.

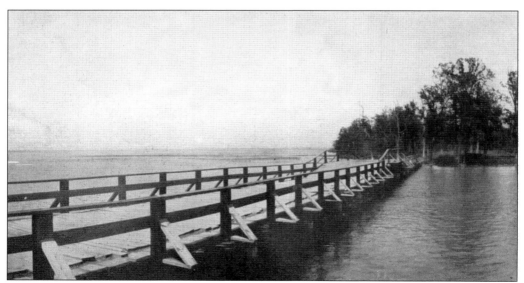

In 1896, a board bridge without a railing was built across the river, connecting the east and west sides of the Mississippi River outlet. After a prominent citizen's carriage tipped off the side, a railing was added. Sentries composed of Bemidji's early citizens guarded the bridge following the Battle of Sugar Point, to protect the town from any surprise attacks from unfriendly Indians.

When the town heard about the Indian unrest, the men went to Willis Brennan's hardware store on Third Street and got all the guns he had. The women and children congregated in the county's first courthouse, seen here, on the corner of Beltrami Avenue and Fourth Street. Elizabeth Arnold recalled how she and her sister got the giggles during the long night and were promptly rebuked by the older folks.

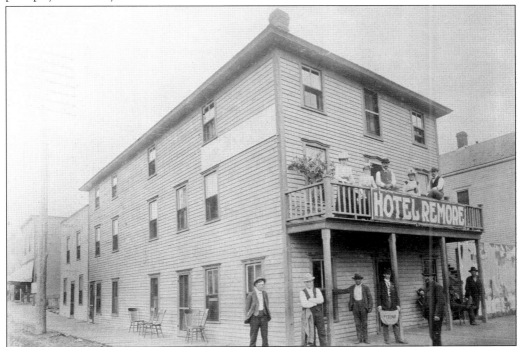

Ernie Bourgeois, an early timber cruiser, arrived in Bemidji just at dusk on October 10, 1898, and got a bed at the Hotel Remore. The next morning, he was rousted out of bed to make room for one of the militia officers who had come in from Duluth during the night to keep order and protect the residents. The arrival of the troops soon restored calm to the city.

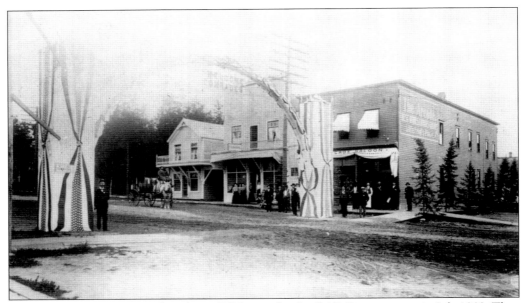

Volunteer carpenters erected Arches of Welcome for the GAR Encampment in July 1903. They built a new 600-seat grandstand in the city park and constructed a dancing pavilion at the corner of Second Street and Beltrami Avenue. The program opened with the introduction of Chief Bemidji, who was on the viewing stand. This photograph was taken at the corner of Minnesota Avenue and Fourth Street.

In 1898, upon hearing that R.H. Carr, a Civil War soldier, needed a place to be buried, Freeman Doud donated a portion of his land, which became the GAR block of Greenwood Cemetery. Carr (1839–1898) was the first to be buried. Doud was himself a Civil War veteran, and when he died, on February 26, 1909, he also was buried in the GAR block.

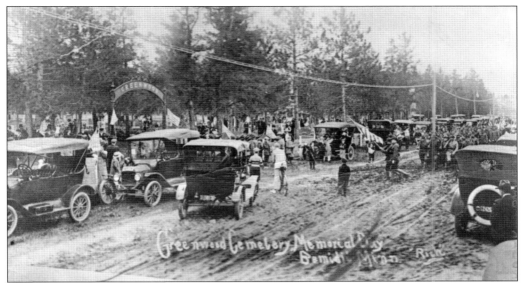

The observance of Memorial Day in Bemidji included a march to Greenwood Cemetery. Organizations were asked to assemble at a public location, such as city hall or the high school. The 1932 parade, seen here, included the Boys Band, Company K, the Forty and Eight, the American Legion, Veterans of Foreign Wars, the GAR and the GAR Circle, Spanish-American War veterans, and the Legion Auxiliary.

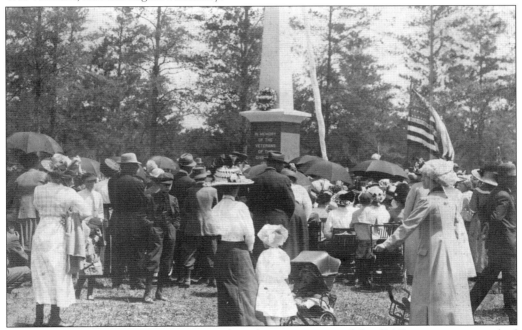

About 50 people attended a ceremony when the cornerstone of the GAR monument was laid on November 19, 1912, in Greenwood Cemetery. A copper casket was sealed in the stone, which contained newspapers, a Lincoln bronze medal, a GAR badge and button, a small American flag, and a piece of pine stump from the Andersonville prison. The monument was dedicated on Memorial Day 1913.

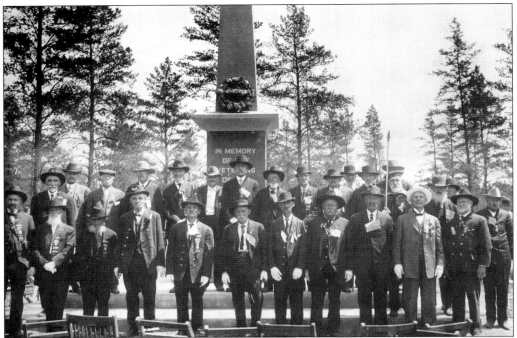

This photograph, taken on Memorial Day 1913, shows members of Bemidji's R.H. Carr Post in front of the monument they had just unveiled. They are, from left to right, (first row) William Schroeder, H.P. Mentor, E.A. Cross, Leonard Freeman, G.P. Irish, ? Whitney, George Cheney, G.G. Foster, past commander Col. E.B. Wood of Cass Lake, department commander W.H. Roberts of Minneapolis, and Nils Trulson; (second row) Harrison Pendergast, J.L. Phillippi, "Dad" Palmer, Oscar Miner, George Smith, Joe Williams, T.P. Garrigan, Joe Bogert, A.A. Howe, C.H. Williams, ? Farris, J.M. Fuller, T.J. Martin, ? Marcot, and J.W. Heath. Commander L.G. Pendergast was present but outside the range of the camera. The women of the GAR Circle (below) included, in no particular order, Martha Cole, Tharsille Villemin, Louisa Parker, and Augusta Schroeder.

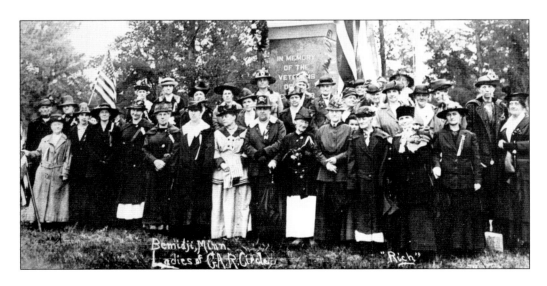

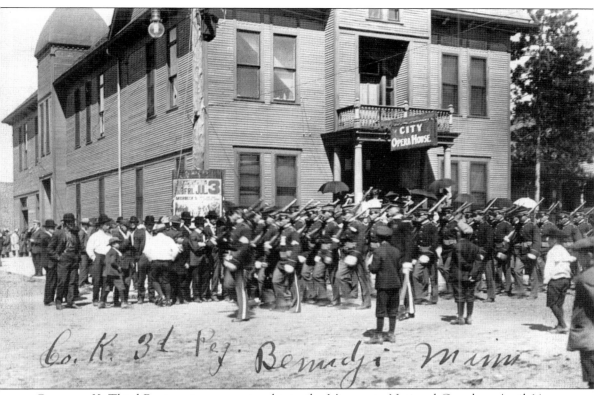

Company K, Third Regiment, was mustered into the Minnesota National Guard on April 14, 1908. The basement of the city hall was used as an arsenal. They held their first military ball on May 27, 1908. Capt. Adam E. Otto, an old soldier of the regular army, was in charge of the newly formed company. They attended their first encampment at Lake City. On June 15, 1908, they marched to the Great Northern depot, accompanied by the girls' Blue Cross association and the Bemidji City Band. Company K remained in camp at Lake City for 10 days and returned home on the midnight train from Crookston on June 25. The company consisted of three officers and 73 enlisted men. This photograph shows them when they assembled at city hall on July 4, 1908, in their new blue uniforms. The company took pride in its armory, which was considered one of the best in the state. It was located at Fourth Street and Bemidji Avenue and was later referred to as McNabb's Armory.

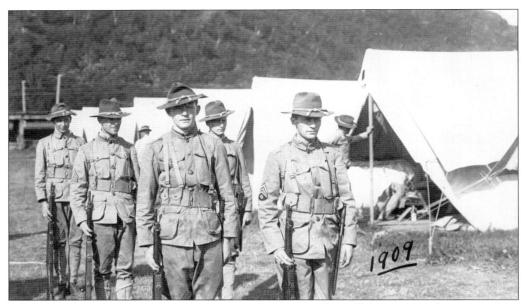

1909

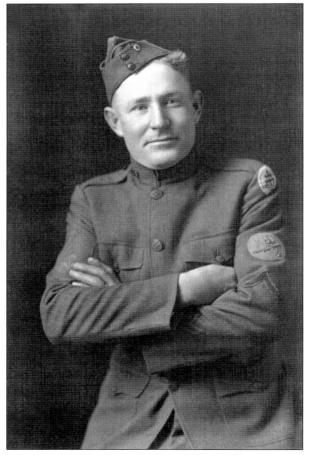

Camp Lakeview was the scene of the annual encampment of Company K in June 1909. 1st Sgt. Harry F. Geil is seen above. The honor of orderly for Col. Charles Johnson—a coveted position—went to Claude Brenneman one day and to William Grimoldby on another. Bemidji defeated Hibbing in a game of baseball in which Carl Mitchell and Warren Gill were battery for Bemidji and Andy McNabb acted as umpire.

Charles Van Masoner was working as an automobile mechanic when he enlisted in the Aviation Section of the Signal Corps. He and 22 other recruits assembled at city hall and were escorted by the Home Guard to the train depot on December 11, 1917, where they were serenaded by the Bemidji City Band. These volunteers were the last who could choose their service before the draft took effect.

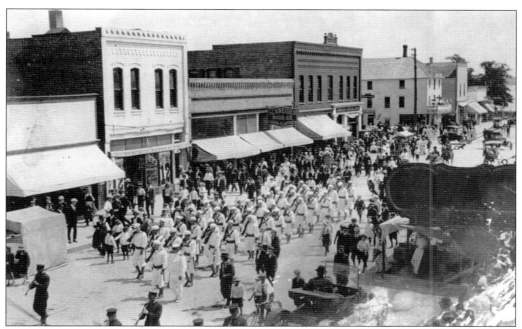

The naval militia was mustered in on June 14, 1915, with 52 young men under the command of Earle A. Barker. They formed the Fifth Division of the Minnesota Naval Militia. The project of securing an armory was undertaken immediately by the Civic and Commerce Association. A bond issue passed on February 20, 1917. Local businessmen subscribed $1,500 to buy the lots from the Bemidji Townsite and Improvement Company on which to build the armory. The appropriation from the state armory board was finally made on April 16, 1917, shortly before the United States entered World War I, putting a complete stop to all plans that had been made for building the armory. The naval militia unit was called to service, and the project came to a standstill.

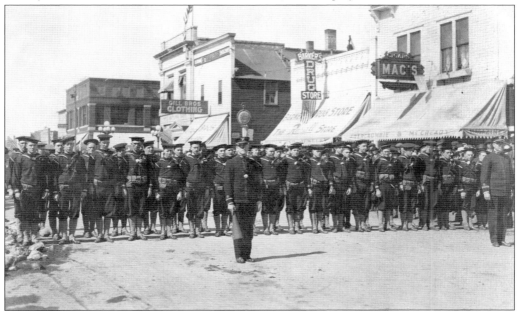

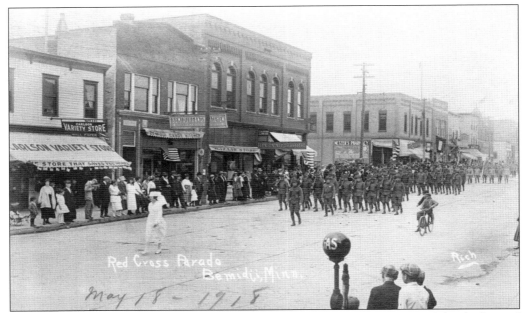

Several organizations were represented in the Red Cross Parade on May 18, 1918. Schools, farmers' clubs, fraternal orders, and military organizations took part in the gigantic pageant. The Bemidji City Band, Home Guard, 4th Minnesota Guard, GAR post, and Ladies of the Circle formed at Eighth Street and headed the parade as it started down Beltrami Avenue.

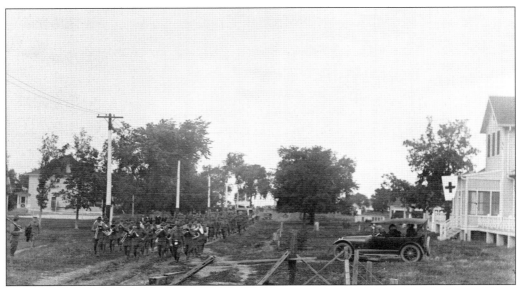

Camp J.D. Yost was the name of the first annual camp of the 21st battalion, Minnesota Home Guard, which was held at Red Lake during the Red Lake Fair. This name was selected to honor Maj. John Dixon Yost, who was head of recruiting in Minnesota prior to the passage of the manpower bill on September 12, 1918.

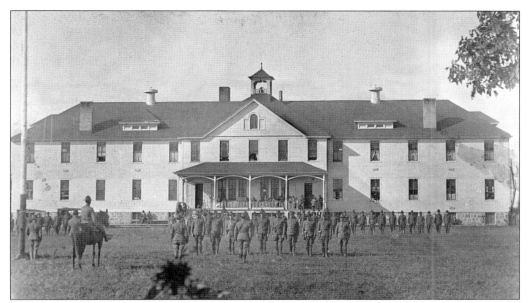

Camp Yost, the first annual encampment of the 21st battalion, Minnesota Home Guards, got underway on September 16, 1918. Besides the Bemidji company, commanded by Capt. Scott Stewart, the companies of Bagley and McIntosh were also represented. Guard duty was inaugurated, and the camp got down to business. The government turned over the Indian school building to the battalion, and it was occupied by the officers as headquarters.

Bemidji Day at the Red Lake Fair was celebrated on Tuesday, September 17, 1918. Major Yost arrived at the encampment with other military staff in a car accompanied by E.H. Denu after coming to Bemidji in his special train car, the Soudan. The band furnished the music and was a big hit. Schools were closed for the day to allow teachers to attend the fair and encampment.

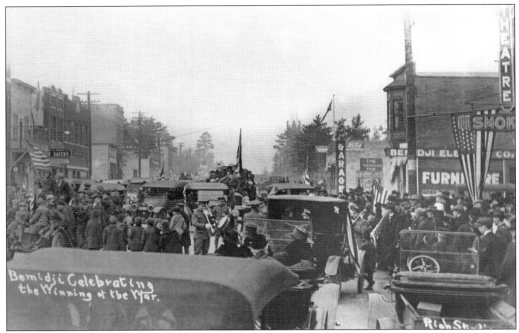

Bemidji enjoyed a wild day of celebration that commenced before daybreak and lasted until the wee hours on November 11, 1918. With the announcement of the signing of the surrender of Germany, whistles shrieked and bells rang out. The fire bell of the city was too slow for many, and willing hands applied a hammer to hurry its notes along, cracking the bell in the process.

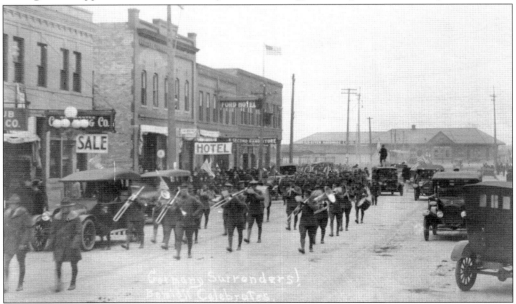

In the afternoon, there was an impromptu parade headed by the 21st Home Guard Battalion Band. The line was made up of scores of gaily decorated vehicles packed to the fenders with noisy celebrants. The band played at various points and merrymakers took to the pavements and danced. On a big truck was the GAR drum corps, which lent its stirring staccato to the noise.

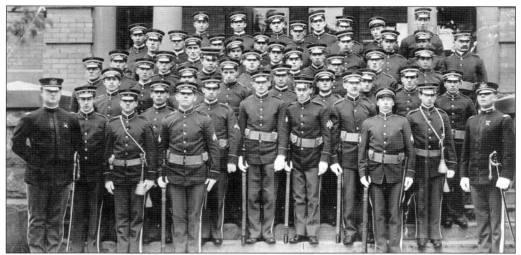

The National Guard poses for a photograph, with commander Lt. Maj. Adam Otto on the far left of the first row and George T. Baker third from right in the first row. On February 7, 1920, Company K of the Minnesota National Guard was mustered in with D.J. Moore as the captain. The company consisted of 107 enlistees. With the assurance that the armory would finally be built, the members of the National Guard unit swung into high gear and attended the first postwar encampment of Company K. The 1920 encampment of the company was held at the same time as the camp for the other companies in the state, but was held on the fairgrounds in Bemidji instead of at Fort Snelling because of trouble with strikers at the mills of the Crookston Lumber Company.

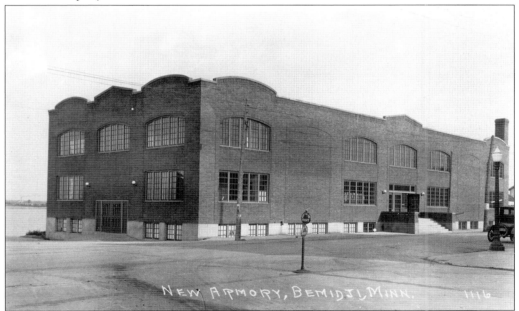

After the war, agitation was resumed for the construction of the armory. The Civic and Commerce Association decided to try for a double appropriation if a National Guard unit could be organized in the city in addition to the naval militia division. The National Guard was organized in 1920 and the armory was completed on February 24, 1921. It was dedicated on May 2, 1921.

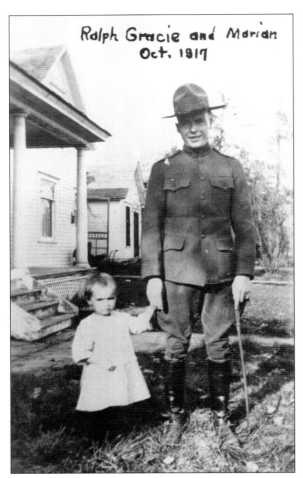

Ralph Gracie and Marian
Oct. 1917

At age 23, while a student at the University of Minnesota, Ralph Gracie applied to be a first lieutenant in the Aviation Section, Signal Officers Reserve Corps. After completing flight training in Scotland and England, Gracie was assigned to the Fourth Pursuit group RAF. On August 12, 1918, Gracie was part of a vicious air fight over France and failed to return from the mission. Four of the pilots were on patrol duty on the coast of the North Sea when they were attacked by seven German planes. His plane went down in flames into the sea. After the Armistice, his body was located in a German cemetery, where it had been buried on August 13, 1918. His remains were brought to Bemidji to be buried in the family plot at Greenwood.

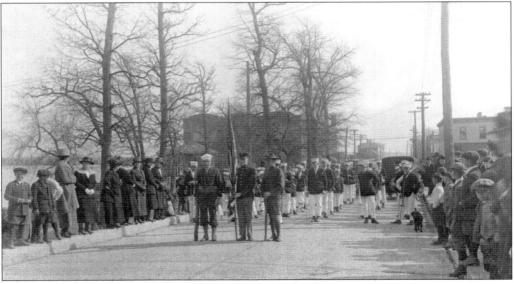

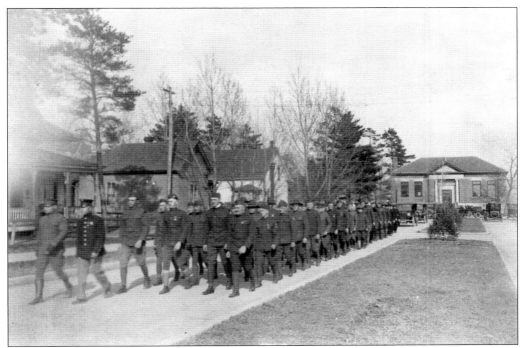

The Gracie funeral procession moved north from the new armory, past the library, left onto Fifth Street, and then north on Beltrami Avenue. The funeral took place before the center boulevard was removed from Fifth Street and before the Masonic temple was built on the corner of Bemidji Avenue and Fifth Street.

The Gracie funeral procession is seen here marching up Beltrami Avenue past the Methodist church at Ninth Street. Services were held at the new armory on April 17, 1921. The pallbearers consisted of six commissioned officers, three of the Navy and three of the Army. Members of the 21st Battalion Band of the Minnesota Home Guard led the procession to the cemetery.

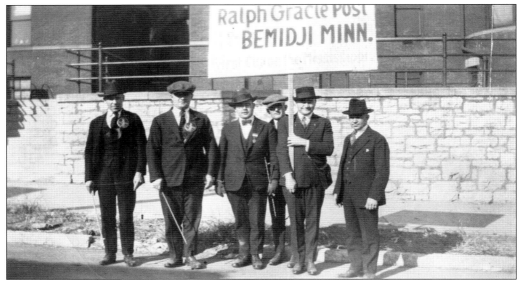

The Ralph Gracie Post of the American Legion was organized at a meeting in the clubrooms in June 1919. Temporary officers were H. Mayne Stanton, Nat Given, Whitney Brown, and William Eberlien. Members in this later photograph were identified as attorney Charles Pegelow; Fred Fraser, *Pioneer* reporter; Rudy Welle; Stub Haleston; and Earle Barker, druggist.

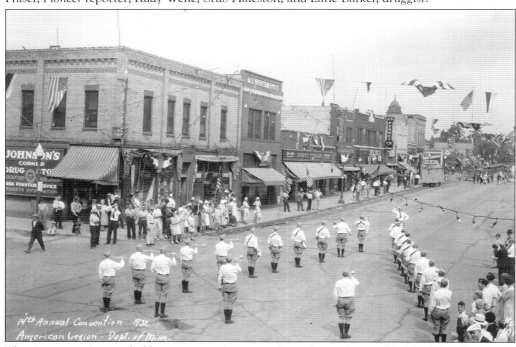

The American Legion held its state conference in Bemidji on August 21–24, 1932. The parade started at Fourteenth Street and Minnesota Avenue and covered 40 city blocks, requiring one hour and 40 minutes to pass a given point. More than 30 musical organizations took part in the afternoon parade. W.H. Bender, E.W. Johnson, John Erickson, and C.A. Iverson headed the organization of the Forty and Eight.

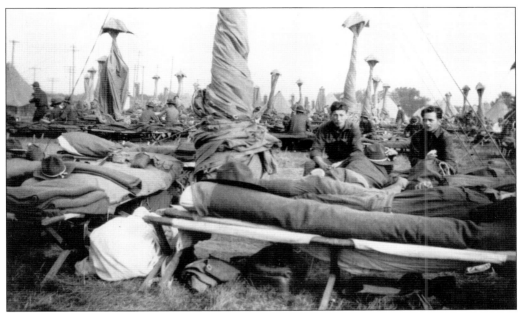

Dick Gravelle and Eddie Damon were part of Company K, the Bemidji unit of the 206th Infantry that attended a two-week encampment at Lake City from July 8 to July 22, 1927. Company K consisted of 51 enlisted men and three officers: Capt. Horace Robbins, 1st Lt. William Howell, and 2nd Lt. Harold Hurlocker. Kenneth Caskey was first sergeant, and Ira P. Batchelder was the supply sergeant.

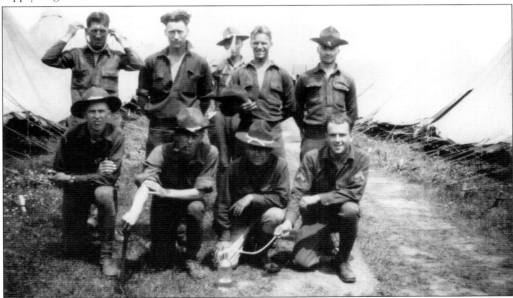

The cook detail, consisting of Red Martinson, Emory Howell, and Mess Sgt. Fred Bourcier, left early to prepare for the opening of the camp. Seen here posing together at camp, in no particular order, are Louis Nygaard, George Olson, Milton Rolkey, Frank Beard, Adolph Rudy, Red Campbell, Porky Miller, and Swat Stevens. Some other members not in the photograph were Roy Bly, Fats Bruggeman, Fritz Hansen, Bernie Howell, George Olson, George McPartlin, and Charles Reed.

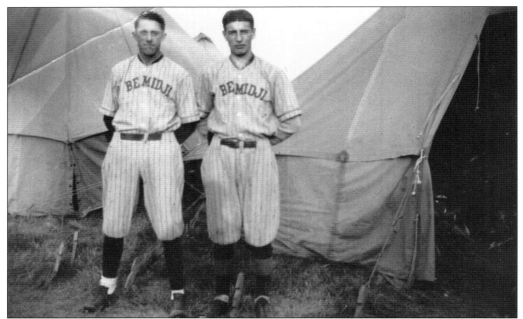

Emory Howell and Dick Gravelle wear their Bemidji baseball uniforms. They likely played against another team such as Brainerd or Bagley while at the camp. One of the memorable events at Camp Maloney was a three-hour parade on an exceptionally hot day when more than 30 men fell out exhausted. Only one member of the Bemidji unit fell out, however. Also, George McPartlin qualified for a record in the rifle range shooting.

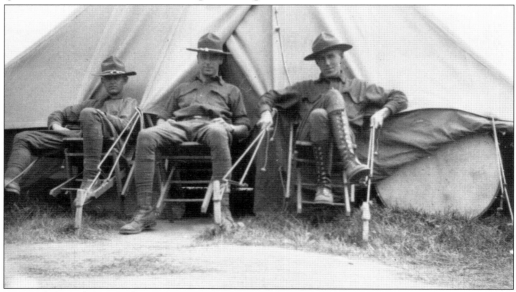

Pictured from left to right in a quiet moment at camp are Charles Reed, Ira P. Batchelder, and Christian Christoferson. Batchelder and Reed were members of the naval militia in World War I. Batchelder owned and operated the Bemidji Woolen Mills. Christoferson was an instructor and served as the principal of Bemidji High School in the 1930s. On June 14, 1940, Company K was changed to Company H Anti-Aircraft Unit.

Six

TRANSPORTATION

Bemidji was justifiably proud of this beautiful outlet to Lake Bemidji, and when the Scanlon Gipson Lumber Company dammed the river just a short distance below the outlet in June 1900, village and county authorities united and authorized placing a charge of dynamite below the dam to release the precious waters, clear the runway, and rid the village of the stench of dying fish.

Mississippi River, outlet of Lake Bemidji, Bemidji, Minn.

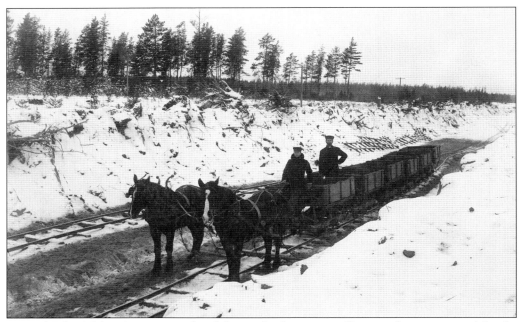

In 1905, John Moberg's crew completed the tracks that eventually carried passenger and freight traffic into Bemidji. Moberg acquired a reputation as a dependable railroad builder and completed the tracks on the west side of town for the Soo line in April 1910. He also conducted a lumber camp at Gull Lake near Tenstrike during the winter of 1904–1905, and logged at Akeley the following year.

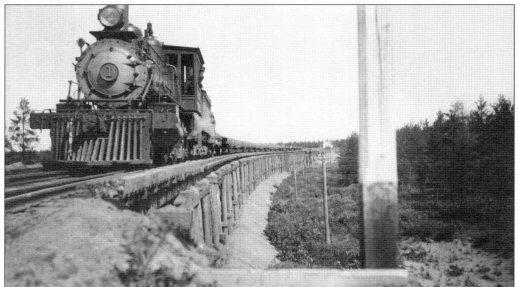

The trestle for the Minneapolis, Red Lake & Manitoba Railway passed over the tracks of the Great Northern. J.J. Jinkinson completed all the bridge and trestle work in March 1905. This small logging line went from the north shore of Lake Irving to Lower Red Lake and also provided passenger and freight service. It was referred to as the Molander line, named for the district manager and ticket agent, Alfred Molander.

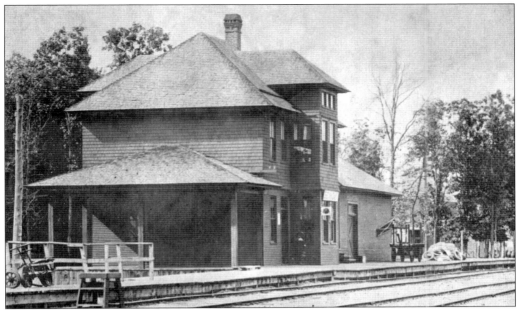

The original Brainerd & Northern passenger and freight depot was between First and Second Streets on the east side of Bemidji Avenue. The building later served as the freight depot of the Minnesota & International after the Union depot was built in 1911 for M&I and Soo passengers and express.

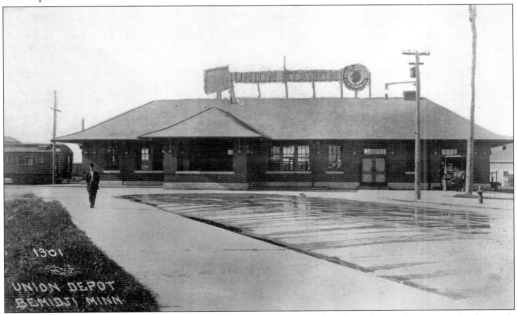

The Soo line was intended to pass on the north shore of Lake Bemidji, and it was only through vigorous effort by the Bemidji Commercial Club that a right-of-way was secured through the city. The first regular train pulled into the station on November 14, 1910. Mary Brinkman was the first female passenger from Bemidji. Construction of the Union station began immediately and was completed in 1911.

James Graser (left) and ? Lackie are seen here hauling the mail in Buzzle Township. Graser was a World War I veteran who farmed and worked as a rural mail carrier. Each carrier was required to furnish his own wagon and horses. It took a good horse to draw such a wagon over country roads in all kinds of weather and all seasons of the year.

Earl Geil crosses the rustic bridge along Lake Boulevard with his horse in September 1907. In May 1914, the street commissioner condemned the bridge as unsafe for teams or automobiles, and the bridge was rebuilt across the scenic ravine. Geil was the proprietor of the Hotel Remore. Among other things, he served as chief of the fire department and Beltrami County treasurer.

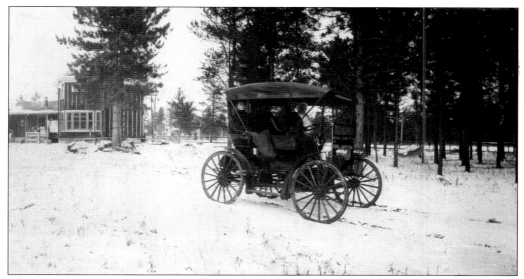

This automobile was reported as the first car in Bemidji. It is parked at the Andrews home in the country, on Fourteenth Street and Irvine Avenue, in 1908. This was the site of the Bemidji Rest Home in the 1940s. On October 20, 1908, T.J. Andrews advertised a span, or horses, a wagon, a sleigh, and a two-seated buggy, for sale. Apparently, he intended to keep the new car.

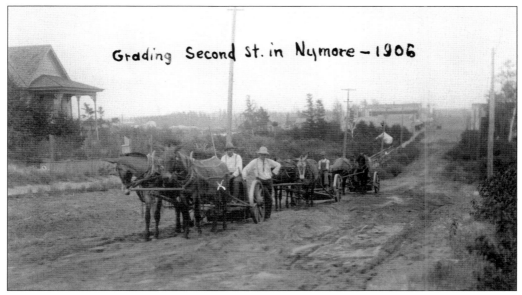

Grading Second St. in Nymore – 1906

Sam Malzahn (standing) works with a crew grading Second Street in Nymore in 1906. In October of that year, work began on a two-room addition to the Nymore school. No doubt Alice Pendergast and Mary Martinson, the Nymore teachers, were happy with the improved streets and more spacious quarters.

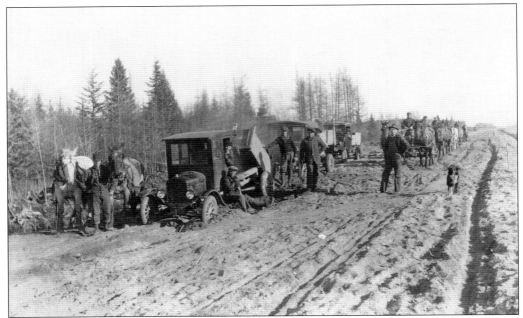

Sometimes the roads made travel difficult, making it necessary to bring out the shovels and the horses. Seen here are Axel Wickner, in the first truck, and David Day, in the window of the second truck. Both lived in Northern Township. Wickner died at the very young age of 20 on January 18, 1929, in Bemidji.

Seen here from left to right are Vera Cameron Falls, Estella Gracie Pogue, Tharsille Villemin, and Frank Pogue. Estella Gracie married Frank Pogue in Bemidji on June 3, 1912, and Vera Cameron married John Falls in Bemidji on June 9, 1913. Villemin was the widow of Constant Villemin, who served in the Civil War. Both Villemin and his wife were active in the Bemidji GAR post.

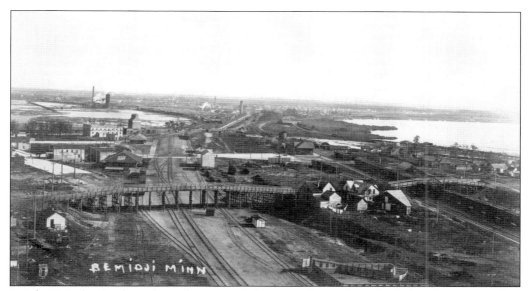

In July 1911, the Soo line planned to put a viaduct over the tracks at the Irvine Avenue crossing. Mayor John Parker pointed out that unless a new viaduct was built to go over both the Soo and the Great Northern tracks, teams would have to haul over one and then over the other, there being 30 feet between the two. Despite his concern, this appears to have happened.

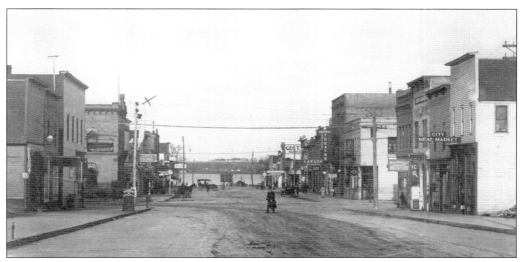

This photograph looks east down Third Street toward the lake and the bandstand. Visible on the right are the City Meat Market, Joe Blondo's hotel and restaurant, the Grand Hotel, and the Brinkman Theatre. This photograph is dated between 1906 and 1910 because the Brinkman Theatre opened in 1906 and the first paving was not done on Third Street between Minnesota and Beltrami Avenue until August 1910.

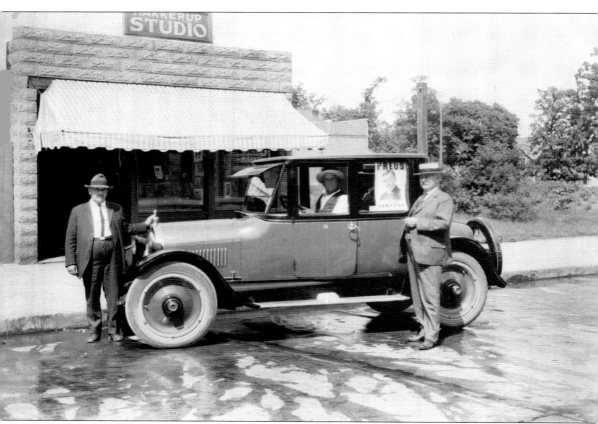

Sherman Bailey (left), Jacob Preus, and his chauffer are parked in front of the Hakkerup photography studio on Third Street. Bailey served on the city council, was the Bemidji chief of police, and served for many years as the state game warden. Preus was the principal speaker at the Memorial Day services in Bemidji in 1914. Bailey was chairman of the council committee that planned the day and highlighted the services of the GAR veterans. A dinner was held afterwards at the Markham Hotel. Preus visited Bemidji again on June 17, 1915, to view the new normal school grounds. Preus ran for governor in 1920—note the election flyer in the window. He was elected on November 2, 1920, and served two terms as governor. In the aftermath of World War I, Minnesotans sought a leader who would restore prosperity and calm following years of strife and deprivation. His political savvy, combined with an apparent desire to correct inequalities, made Minnesota's 20th governor a surprisingly prolific reformer.

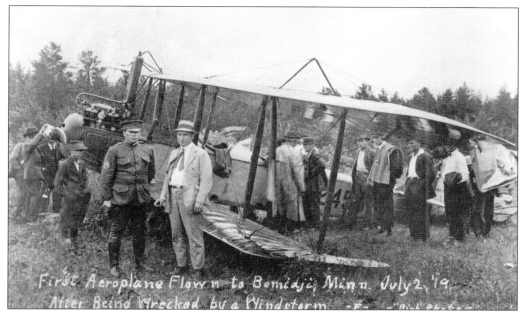

The first airplane in Bemidji was this biplane, built in 1915. Harry Slough helped Katherine Stinson assemble it after it arrived by freight. The plane was displayed at the Beltrami County Fairgrounds in 1916. In 1919, Lt. N.B. Mamers flew it to Bemidji and it was to be the leading attraction for the Fourth of July celebration, but it was damaged in a rainstorm on July 2.

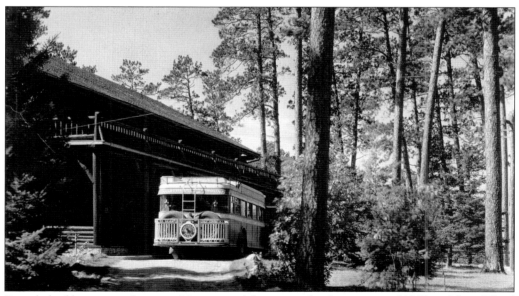

Bemidji had bus service between Nymore and downtown by the summer of 1917, and from Third Street to Thirteenth Street every day from 6:00 a.m. to 11:00 p.m. The fare was 5¢. Service between Bemidji and International Falls was available as early as 1918. The Northland Greyhound lines began in 1929. This appears to be an early Greyhound bus at one of the parks.

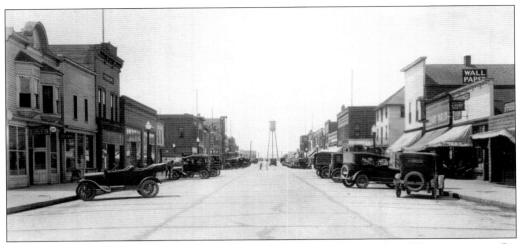

This photograph looks west down Third Street around 1917, showing the 1909 water tower. On the right are the Hakkerup photography studio, a livery, and the Remore Hotel. On the left, about halfway down the second block, is Laqua's Quality Store, at 206 Third Street. Ole Laqua was born in Norway and was an early settler in Bemidji. His shop sold men's clothing and shoes.

This is the Soo line railroad bridge looking toward the Crookston mill, on the south side of Lake Bemidji. Crookston Lumber built its first mill in Bemidji in 1903, and then bought the Bemidji Lumber Company's mill from W.A. Gould in 1907. That acquisition made Crookston Lumber one of the biggest lumber companies in the United States. One mill was damaged by fire in 1917, and another mill burned in 1924.

Seven

HOTELS AND TOURISM

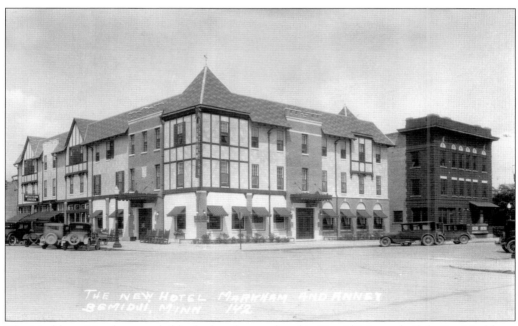

The Markham Hotel was probably the best-known hotel in Bemidji. It was built by Joe Markham in 1899 and sold to Wilbur Lycan in the early 1900s. The Lycans lived in an apartment in the hotel, which remained in the Lycan family until the 1970s. It was the scene of countless banquets, wedding receptions, and meetings. It is always spoken of with nostalgia by those who worked there and those who visited.

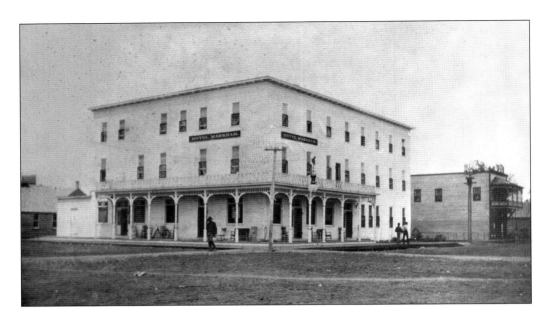

Joe Markham had the Markham Hotel ready to open by Christmas 1899. He added a saloon and went to gambling the first year; the place was filled with traveling men. He charged 50¢ for his meals and $2 a day to stay there, a big price for those days. The first year, Markham made $8,000. His slot machines took in between $20 and $30 a day. George Cook, the superintendent of the Brainerd Lumber Company, used to stay there, and later, he moved into the Remore Hotel. The 1899 photograph above shows the Hotel Nicollet on the right. The photograph below is from a later date, after the annex was added on the right. The hotel had many famous guests, including the Harlem Globetrotters and boxer Joe Louis.

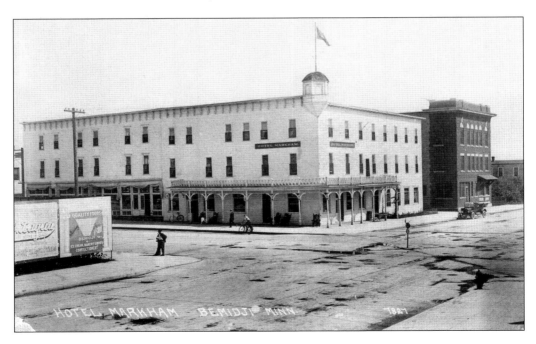

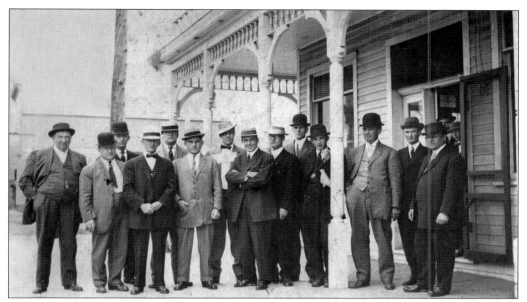

Mayor Charles Vandersluis and the Commercial Club held their usual meeting at the Markham Hotel. The hotel had a special room for the club called the Bemidji Room. The dining room tables were always set with linens, silver, and fresh flowers, summer and winter. The Markham was a place for business, but also for special occasions such as birthdays, anniversaries, and wedding celebrations.

Eleanor Roosevelt visited Bemidji on October 13, 1955, and stayed at the Markham. She commented in her journal about the beauty of the area, but also on the chilly evening and Bemidji's reputation as the icebox of the nation. Laura Goodmanson (left) assisted Roosevelt with her stay. Goodmanson went to work for the Markham around 1932, and eventually ran the hotel until 1971, when she retired.

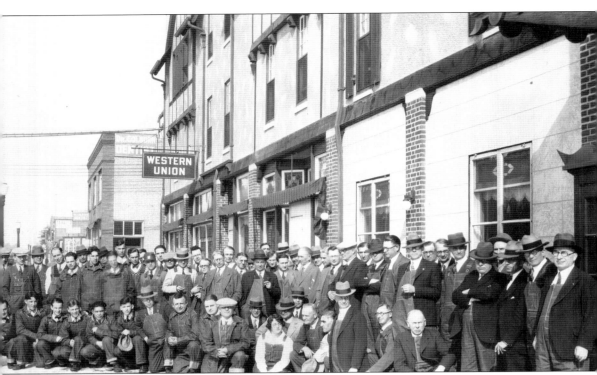

The Bemidji Civic and Commerce Association met at the Markham on March 7, 1928, wearing denim to indicate their desire to do their share of the association work during the coming year. The attendance established a new record for noon luncheons, making it necessary to use the large dining room. Following the luncheon, a group photograph was taken. Although 64 members attended, regrettably, many are not identified. The first row includes, in no particular order, Henry Simons, Ray Vipond, Art Stevens, James Sexton, Dr. A.V. Garlock, Henry Krebs, George Rhea, Earl Barker, Walter Brooks, J.P. Lahr, George Baker, and Charles Battles. One woman, Beth Evans Yaple, was the secretary for the association. Some of the men standing are, in no particular order, Wilbur Lycan, Fremont Ditty, Fats Bruggeman, Glen Bethel, Addison Goddard, Hugh McCormick, A.J. Naylor, Happy Halvorson, John West, Bill Nelson, Louis Caskey, Bert Naylor, H.Z. Mitchell, Judge Graham Torrance, Dr. Daniel McCann, Clarence Smith, Frank Lycan, Rev. Lester Warford, A.T. Carlson, Anton Hoganson, George Knight, and Alex Doran.

The Remore Hotel was the first building constructed on the west side of the Mississippi River inlet. J.F. Remore and his son Guy built it in 1895. Earl Geil was the clerk and George McTaggart helped Remore. In 1898, Geil and McTaggart purchased it for $3,000. Business was good. The second floor was used mostly for the lumberjacks; sometimes, the rooms were so full they had to sleep three in a bed. The traveling men mostly stayed on the main floor. Those rooms were in better condition and cost more because the bedsheets were changed every day. For the lumberjacks, the sheets were washed once a week. Geil recalled that they had a stove in the hallway, one in each office, and one in the dining room. They baked all their own bread, pie, and cake and set a nice table for the downstairs trade, which included doctors, gamblers, and businessmen. The lumberjacks were fed 30 at a time in five-minute seatings. The hotel burned in 1926.

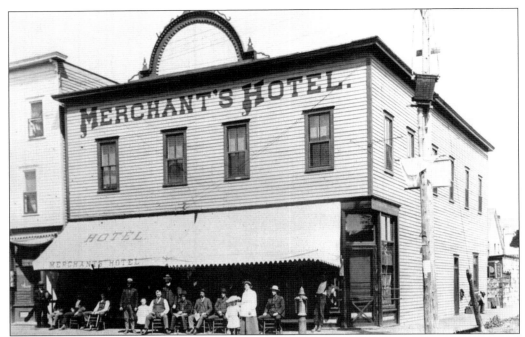

The Merchants Hotel was built at 202 Minnesota Avenue around 1905. W.E. Hazen, seated seventh from the left in the white shirt with his small daughter at his side, operated it. Hazen conducted the hotel, and J.E. Kinney operated the saloon. The wooden building was destroyed in a spectacular fire on February 6, 1907, which destroyed seven buildings on Minnesota Avenue, reaching from the corner of Second Street to the alley.

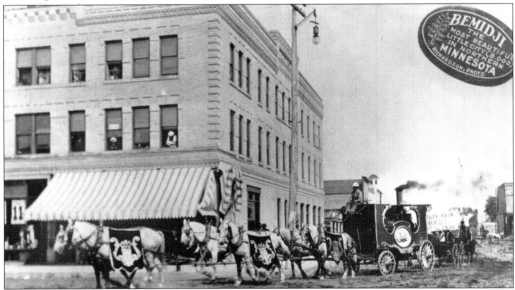

Work began to rebuild the hotel on May 17, 1907. It opened in April 1908 in the new Thome-Mayer Building as the Hotel Burroughs. On May 1, Matt Mayer took over the management and changed the name back to the Merchants Hotel. It closed in 1909 and reopened as the Rex Hotel on July 1, 1910. Here, a circus wagon rounds the corner by the hotel.

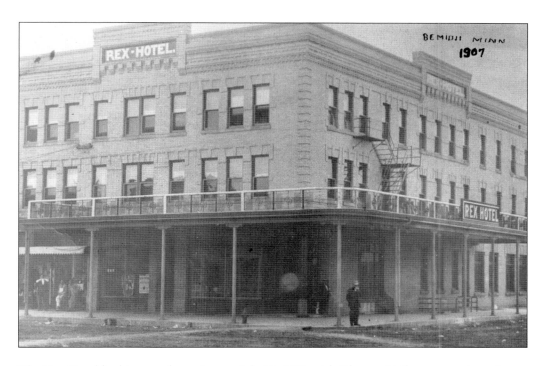

The Rex Hotel had its grand opening on July 16, 1910, with Thomas Bailey as proprietor. It was a first-class hotel, with 65 rooms, all equipped with the most modern of fixtures. It burned on November 5, 1912. The lot remained empty until Morris Kaplan built a grocery store on the corner in 1916. He sold the building to Frank Dewey in 1919. Dewey operated Dewey Furniture on this corner until he retired on May 3, 1941. W.O. Malone then bought the building, but a major fire swept through the entire building in March 1943, destroying the store as well as the apartments on the second floor. The area is currently a parking lot.

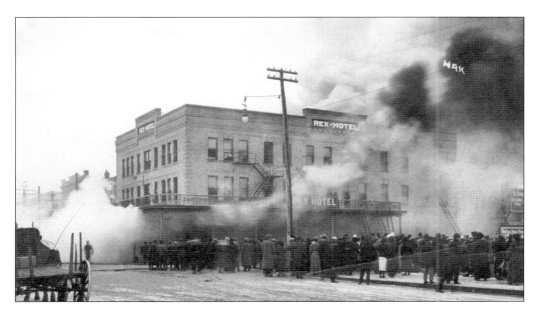

Ole Anderson was the proprietor of the Lake Shore Hotel in 1898. In 1905, he remodeled the hotel, located on the corner of Bemidji Avenue and Second Street, and a sidewalk was built from the old post office to the hotel. By 1921, Pat Stapleton was the owner. He added a new brick front, covered the exterior of the other walls with stucco, and completely remodeled the interior.

Ole and Clara Anderson, their young daughter Ella, and John Croon are seen here at the rear of the Lake Shore Hotel in 1898. John married his wife, Anna, in 1902, and after he died, on December 20, 1919, Anna continued to own and operate the Hotel Nicollet, across from the Lake Shore Hotel, until her death, on September 25, 1963.

The City Hotel, at 313 Beltrami Avenue, was built by J.H. French around 1898. At right, standing at the far left corner of the building are Edwin N. French and Inez French. Fifth from the left is the owner, J.H. French. The City Hotel changed hands on December 11, 1899, when M.S. Maltby took control from Freestone and Gould. The 1900 Sanborn maps show that besides the Markham Hotel, there were also the Brinkman, City, Dewey, French, Svea, Lake Shore, Merchants, and Palace Hotels as well as Scandia House and the Schultz House, for a total of 11 hotels. There were also four female boardinghouses south of Second Street and enough saloons to meet the demands of any thirsty man. The Park Hotel and Saloon (below), at 300–302 Second Street, was owned by Elsie McDougall in 1904.

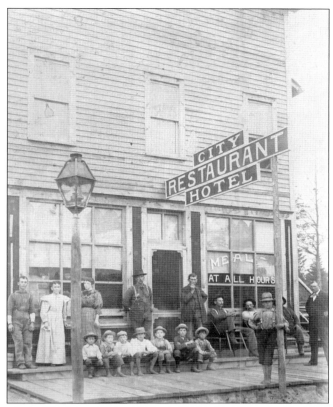

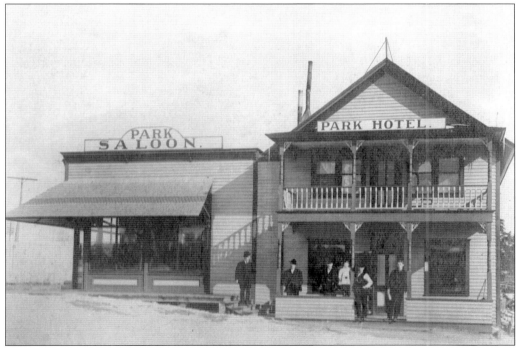

Gustave Jacobi closed a deal in May 1907 to purchase two lots from Frank Mayo and commenced to build the first cottage at Birchmont Beach. He was a Grand Forks banker and came every summer to his cottage at Grand Forks Bay, on the west side of Lake Bemidji. His daughter Geraldine married Roy Russell and went to Canada to live. When she had her first child, she wanted to give birth in the United States, so she came back to Bemidji just in time for Jane Russell to be born, at St. Anthony Hospital on June 21, 1921. When Jane was young, the family spent every summer at the cottage at Birchmont. Her first movie, *The Outlaw*, was never shown in Bemidji, even though she claimed the city as her hometown.

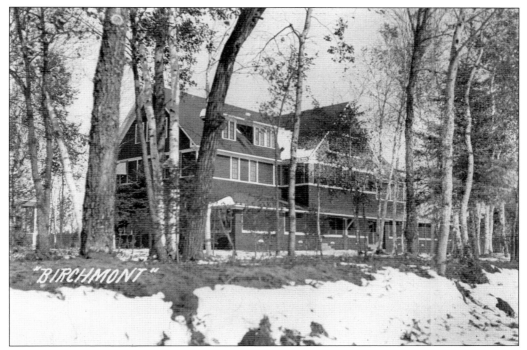

The Birchmont Resort, at the head of Lake Bemidji, was started in 1910 when George Cochran bought land from A.A. Andrews and Frank Mayo and built the first cottage on the property. In 1911, Cochran built one more cottage, and in 1913, he put up three log cabins. In 1915, he constructed the first Birchmont Beach Summer Hotel. It opened on July 29, 1915, and was managed by William Chicester. More than 200 patrons attended the opening banquet and dance. The hotel was small in comparison to the resort buildings constructed in later years, but the resort increased in popularity. Between 1915 and 1920, a clubroom and several more cottages were added. Just as success seemed assured, however, a fire swept through the entire resort on September 2, 1920, and destroyed everything.

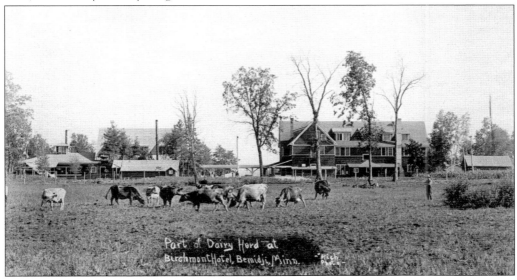

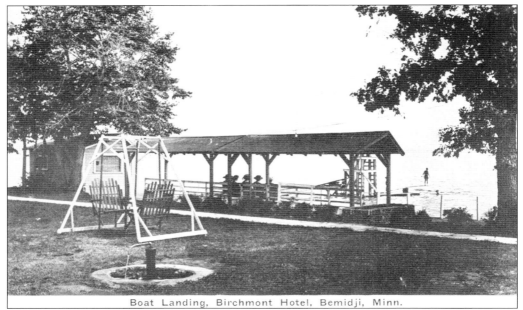

Boat Landing, Birchmont Hotel, Bemidji, Minn.

Responding to the need to replace the former summer hotel, Tams Bixby urged the Civic and Commerce Association to solicit funds to rebuild, and in less than 30 days, stock and bonds of the Bemidji Birchmont Hotel Company had been sold to local businessmen for $44,630, and they were able to proceed. At their first business meeting, 158 Bemidji businessmen were present, as stockholders and bondholders in the new company. The company purchased the land from George Cochran, and construction started in April 1921 on the new hotel, which reopened in June. The hotel employed from 42 to 45 people during the 1921 season and entertained as many as 165 guests in one day, while hundreds were turned away during the two months. Stockholders held a jubilation meeting at the end of the first season.

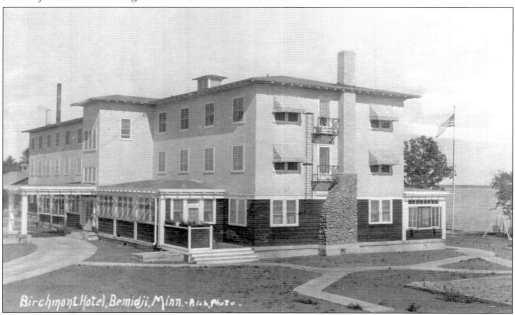

Birchmont Hotel, Bemidji, Minn. - Rich Photo.

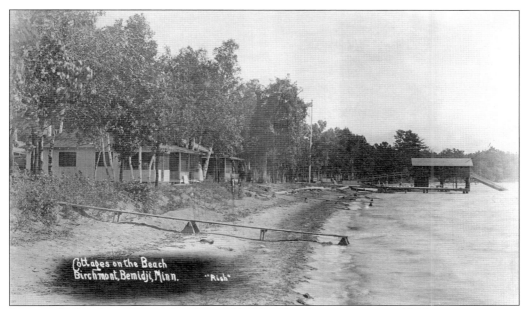

Because the hotel was so popular, the stockholders found it necessary to add 10 more cottages in 1922. These cottages, like the ones above, were held by their owners for years and were quickly sold when they were put on the market. Eventually, the resort covered 14 acres and had 27 cottages. A convention hall and auditorium were built in 1931 to use as a place for dancing and summer conventions. The Great Depression of the 1930s hurt the hotel business, and vacations were a luxury. The hotel company went bankrupt in 1934 and operated under receivership for two more seasons. When the bank planned to auction the property off, the Ruttger family made a bid and acquired it for $39,000. In 1937, Don Ruttger moved to Bemidji and eventually bought the resort (below) from his father and uncle.

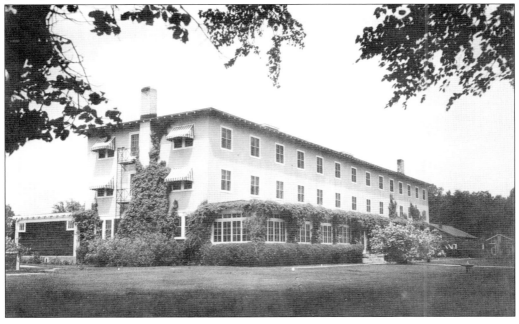

John A. Dalton came to Bemidji in 1902 and was engaged in the hotel business until his death in 1922. The Dalton Hotel was on the upper floor of the building at 215 Beltrami Avenue. The Geo. T. Baker Co. was on the street level. Baker was the official watch inspector for the Minnesota & International, Big Fork & International Falls, and Great Northern railroad companies.

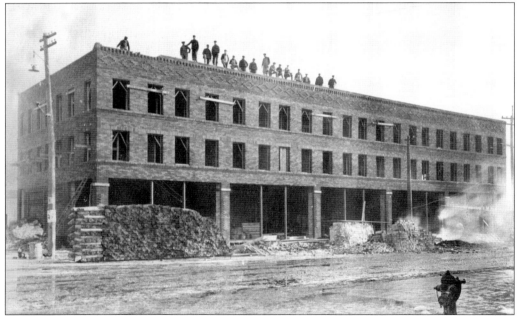

The New Bemidji Hotel was built by Morris Kaplan at 120–128 Minnesota Avenue in 1922. He remodeled the hotel building into a large store in 1941, which included a hardware store. Eventually, the upstairs rooms were divided into two- and three-bedroom apartments. The hotel name is still on the south side of the building.

Eight

BANDS AND MUSIC

Music has been a part of Bemidji entertainment since 1899, when a boys' band was organized to entertain the public. The first bandstand was built at the waterfront in 1899 and was moved several times until a new bandstand was built in 1925 in Library Park. Seen here, from left to right, are John E. Croon, Ole and Clara Anderson, and Ella Anderson. The Andersons and Croon owned hotels in the neighborhood.

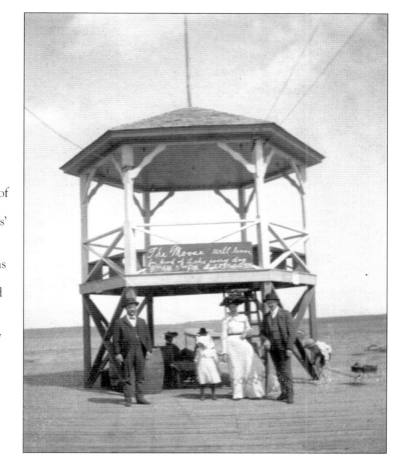

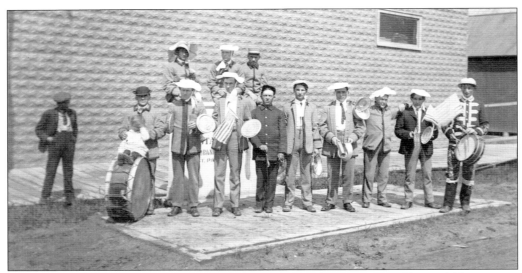

Bemidji's clown band performed at Blackduck during the Northern Minnesota Firemen's Tournament on June 21–23, 1905. The band included, from left to right, (first row) Happy Halverson, H.F. Geil, Lee Heffron, unidentified, Alec Doran, Ray Dennis, Harry Arnold, and George Flemming; (seated) Scott Stewart, Erton Geil, and Ted Naylor. About 20 musicians held their first practice on June 16, 1905, with the intent of forming a permanent Bemidji band.

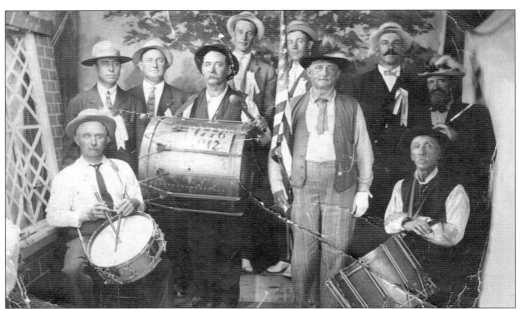

The Buck Tail Drum and Bugle Corp, including C.A. Parker, seen here with the snare drum, was part of the festivities in Bemidji on July 4, 1912. Auto races, interesting water sports, and an exciting baseball game at the fairgrounds were offered to visitors as well as a concert in Library Park. The evening ended with a grand ball at city hall. Activities went from sunrise to midnight.

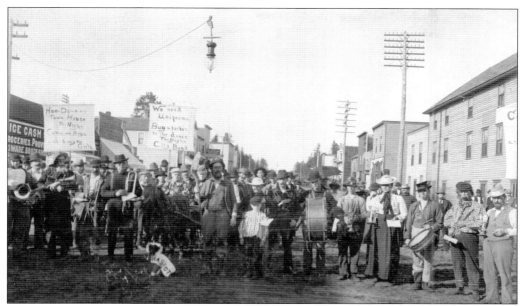

The Bemidji City Band is seen here fundraising for uniforms on Beltrami Avenue on June 4, 1906. Thanks to a generous donation from C.H. Miles, the band received its new uniforms just in time for the firemen's tournament on June 18, 1906. The coat was navy blue with a black braid, with two small gold harps on the collar. The trousers were also blue and striped with black braid.

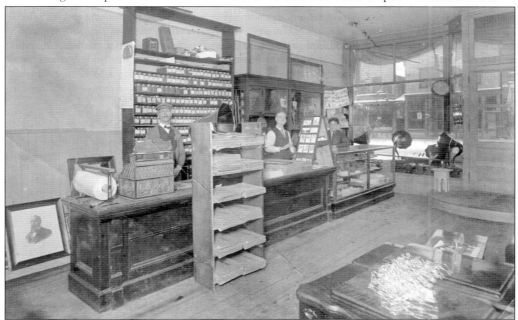

The Northwestern Music Company was opened on November 7, 1908, by J.H. Crouch and W. Henry Williams at 314 Minnesota Avenue. Williams had a questionable past in Crookston, but the two went into business anyway. In April 1909, however, Crouch discovered a flawed contract, and Williams was subsequently charged with forgery. Donald Meikle was the manager in 1910–1911, and the building was next sold to John Bye for a saloon.

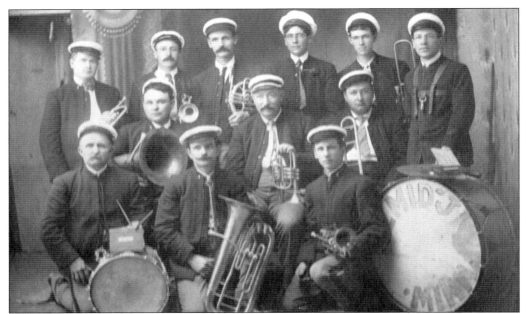

The members of the Bemidji City Band listed on the back of this photograph, dated July 4, 1907, are, in no particular order, Fred Walker, George Ensign, George Pitney, George Kinney, Herb Woods, Fred Ellis, C.H. Parker, George Kling, musical director Tom Symington, Tom Britton, Grant McClure, and H. Nevins. Absent were Harry Geil and Edward Shannon. The band rode in the 1907 Fourth of July parade on a wagon drawn by four black horses.

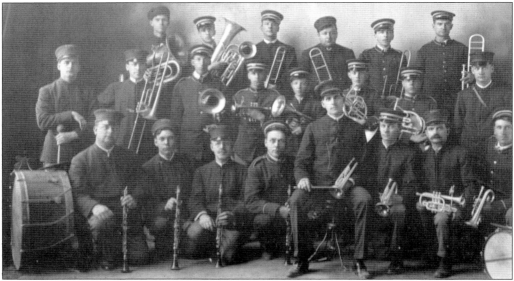

The Bemidji City Band was missing from the Fourth of July celebration in 1908, but it reorganized later in the month with Harry Masten as leader. Among the men kneeling in the first row are, in no particular order, Happy Anderson, Dr. Larson, Harry Masten, and Harry Geil. The second row includes, in no particular order, Wint Ellis, Ernest Neuman, Ed Simons, Clarence Shannon, and Walt Marcum. Among the men in the third row are, in no particular order, Herb Woods, Charles Cummer, and Dr. David Stanton.

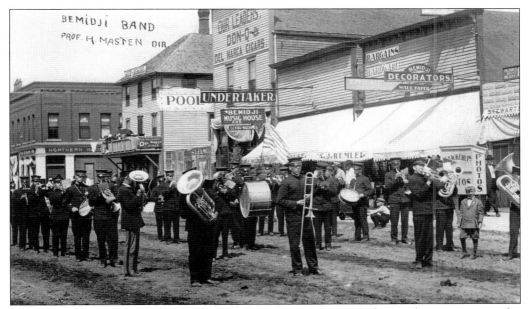

The Bemidji City Band was formally organized in 1905. By 1910, the band was giving regular monthly concerts at the armory under the direction of Harry Masten. The band was named the official band for the 11th Battalion, Minnesota State Home Guards, in February 1918, and appeared with the guard in full uniform when on duty. Clyde Petrie was the manager, and P.R. Peterson was the director.

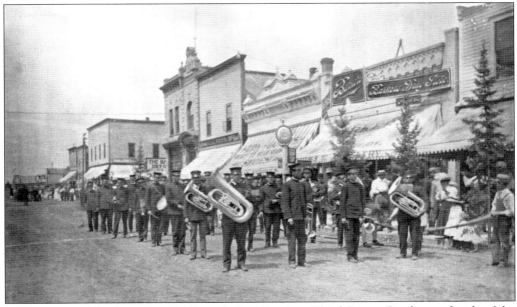

This photograph looks west at the Bemidji City Band on Third Street. On the north side of the street are Barkers Drug Store, the Emporium, Gill Brothers Clothing, and the First National Bank. Earle Barker came to Bemidji in 1900. In 1903, he purchased the Mayo Drug Store at 217 Third Street. Gill Brothers was founded in 1903.

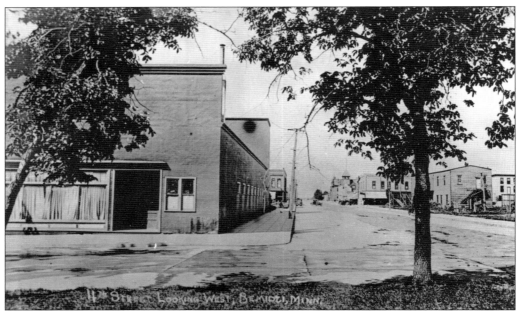

The Armory Opera House was on the southwest corner of Fourth Street and Bemidji Avenue. It was also referred to as the Andy McNabb building. The exterior shot above shows the Armory in 1910, looking west along Fourth Street from Lake Bemidji toward city hall. The interior shot below shows a group playing inside the Armory Opera House. The armory is mentioned frequently between 1910 and 1913. In 1910, Capt. Adam E. Otto reported receipts totaling $605 from band rehearsals, concerts, the fire department, the Elks, the Bemidji dancing club, Quaker doctors, evangelistic meetings, and church socials. The city was to get all excess earnings, but until 1910, there had not been any excess. The armory became the property of the Bemidji Athletic Club in 1913. The building later burned, and the lot eventually became the site of Gary Oil Company.

The Minnesota Piano Company is advertised in this street scene. Telesphore Beaudette is on crutches in front of his tailor shop, at 315 Beltrami Avenue. He was a merchant tailor in Bemidji as early as 1900, but he did not move to Beltrami Avenue until after 1904. Beaudette moved to California in October 1912. This building also housed the City Hotel, Ross Hardware, and the Floyd Brown studio between 1900 and 1910.

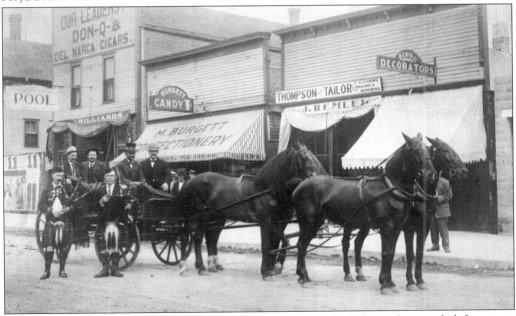

This photograph was likely taken on Third Street when nearly 400 people attended the picnic given by the Scots of Bemidji on August 13, 1911. Music on the bagpipes was furnished throughout the day, and the chief entertainment was when Freda McKinnon danced the Highland Fling. Narsh and Dave McKinnon organized the Sunday picnic along the Mississippi River outlet.

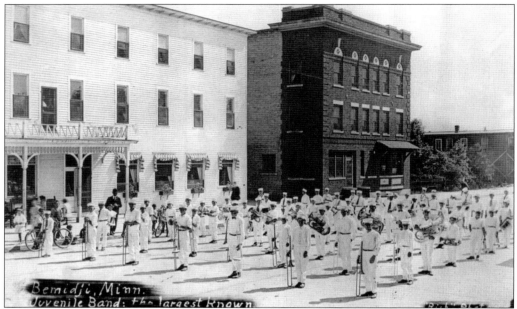

G. Oliver Riggs was hired by the city on January 1, 1919, to take over the 21st Battalion Band. Bemidji's military band gave its first concert under its new director at the Grand Theatre on March 26, 1921. The Bemidji Boys Band was also assured, as 75 instruments had already been purchased and 140 boys had enrolled in the program. Local banks made loans for the purchase of additional instruments.

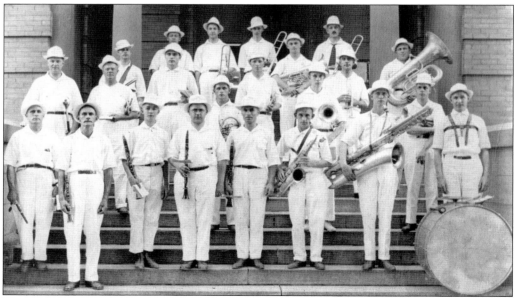

The Bemidji City Band, seen here on the courthouse steps in 1920, included, from left to right, (first row) Paul Foucault, P.R. Peterson, Alfred Peterson, C.L. Pegelow, Charlie Paul, two unidentified, and Tom Newton; (second row) ? Odegard, G. Oliver Riggs, three unidentified, Max Bell, ? Fenton, and Walt Marcum; (third row) two unidentified, Fletcher Grimoldby, unidentified, Elfred Benson, and ? Osborn.

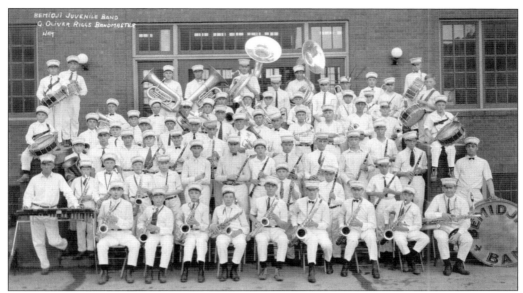

The Bemidji Boys Band was so successful and in such demand that G. Oliver Riggs put out a call for a beginners' band in October 1920. About 75 boys responded. Most of them were about 12 years old. There were no fees to belong to the program, but the boys did have to purchase their own instruments. This photograph of the band was taken in May 1922 in front of the armory.

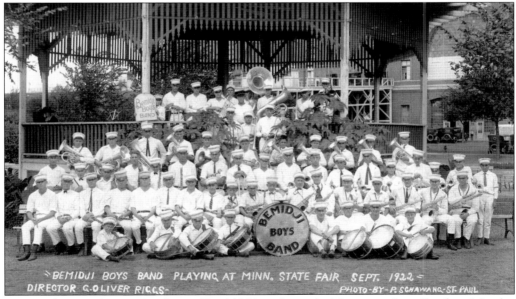

In 1922, the Bemidji Boys Band was offered $800 to play at the Minnesota State Fair from Monday through Friday. A local concert at Library Park in June started the campaign to raise additional funds for the trip. They took first place as the state's best boys' band. Joe Plumer, a mainstay for five decades in Bemidji's music scene, started playing clarinet at the age of 12 with this band.

Gladys Simstren organized a group of students from Lincoln and Central schools into the Melody Band in the spring of 1934, and then divided them into an A and a B band. The instrumentation of the band was cleverly designed by Simstren so that only instruments of low cost could be considered, so that a larger number of children could participate. This photograph was taken in the central gym of Bemidji High School.

The Legion Kiddies drum and bugle corps was organized by Gertrude Sherwood Ness and sponsored by the Ralph Gracie Post No. 14 from 1935 to 1941. Bill Bender was the liaison for the American Legion to the group. Ness and her drum corps achieved remarkable success. Their colorful uniforms and rhythmic drill maneuvers thrilled thousands of spectators at affairs, American Legion conventions, and numerous other events.

Gertrude Sherwood Ness conceived the idea for the Legion Kiddies in November 1929, when she was a member of the Lincoln school faculty. She started the corps with 16 members, all playing snare drums, as a school project. They appeared in 1932 at the state American Legion convention, and the following year, they took their first out-of-town trip to Duluth. Virgil Heathman drove the bus as the band traveled around the state.

In 1941, the group consisted of four tenor drums, twelve snare drums, two bass drums, two cymbals, and twelve bugles. The unit included two majorettes, Zola Belle Holmes and Allen Saeks, and one drum major, Darlene Gray, who served in the corps for nine years. They represented Bemidji at the Minneapolis Aquatennial in 1939. Here, they pose on the steps of the gleaming new Memorial Hall at Bemidji State College.

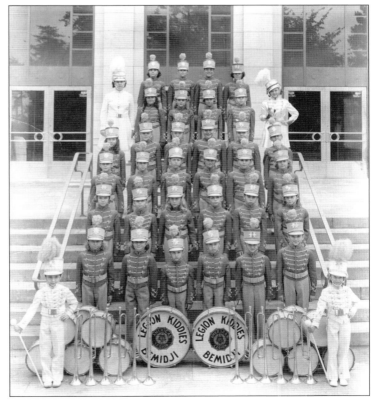

Don "Bear" Samuelson seemed to be enjoying his snare drum and a snow sculpture of Paul Bunyan near the Paul Bunyan House at the lakefront in 1939. The Paul Bunyan House was the headquarters of the Bemidji Civic and Commerce Association. It underwent several modifications before eventually being torn down and replaced by a modern building.

The Maeser Fur Farm Band was composed of 15 musicians from Bemidji and the Maeser Fur Farms, near Hackensack. The band made its first appearance in Bemidji on June 2, 1927, giving a short concert on Third Street. This band was organized by P.R. Peterson, the district representative of Maeser Fur Farms. Peterson was a veteran musician and was well known among Bemidji's musicians.

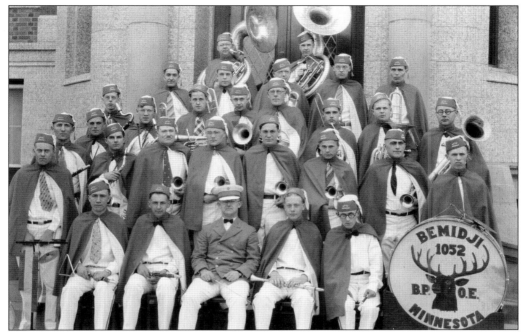

The Bemidji Elks Band was organized in 1927 by A.S. Halvorson. The band had 40 pieces and was directed by E.E. Benson. They gave one of their first concerts at Library Park to entertain visitors from Cavalier County, North Dakota, on June 24, 1927. This Hakkerup Studio photograph of the band appears to have been taken on the high school steps.

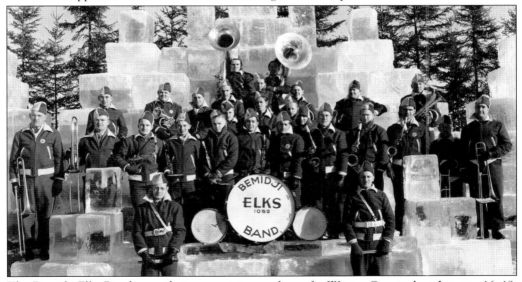

The Bemidji Elks Band wore their new winter uniforms for Winter Carnival on January 16–18, 1939. The jackets were purple trimmed with white. WDAY broadcast from Bemidji. The coronation robes were made by the Works Progress Administration (WPA) sewing project. The Civilian Conservation Corps (CCC) and the US Forest Service constructed the ice throne at the end of Third Street. Joy Batchelder and Marian Stout were the two flower girls accompanying the coronation ceremonies.

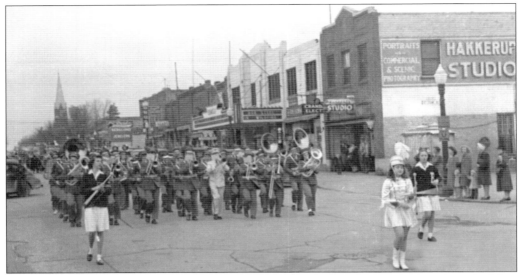

The Bemidji High School marching band was an important part of every parade in Bemidji. They are seen here marching south down Beltrami Avenue between Fourth and Fifth Streets in 1946, led by director Earl Kerns. Herb's Popcorn Stand, Hakkerup Studio, and the Bemidji Theatre are visible along the east side of the street. The American Legion Band was also formed in 1946, with Roy Hester as director.

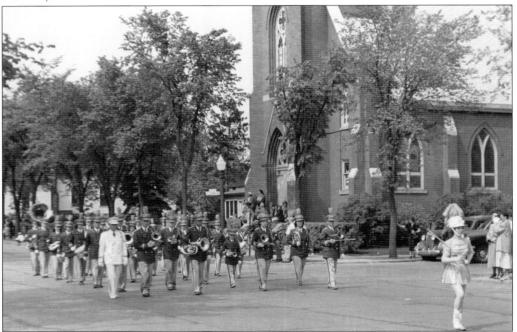

Director Earl Kerns leads the Bemidji High School marching band down Beltrami Avenue in front of St. Philip's Church during the Water Carnival in 1950. Some familiar names from the 1950s bands were Joan Chadwick, Dale Dickinson, Joe Forbes, Carol Goodmanson, Gloria Hill, Donald Heathman, Barbara McDowell, Riley Slosson, John Unger, and Tom Wrolstad. Kerns also organized small dance orchestras that played in the 1940s and 1950s.

Nine

EVENTS

One of the fastest drives of logs in northern Minnesota was made by the Grand Forks Lumber Company, which drove two million feet of logs from LaSalle Lake to Lake Irving in 21 days. W.L. Preble of Bemidji was in charge of the log drive. A hoist was erected on the east shore of Lake Irving, and the logs were loaded and shipped to Grand Forks.

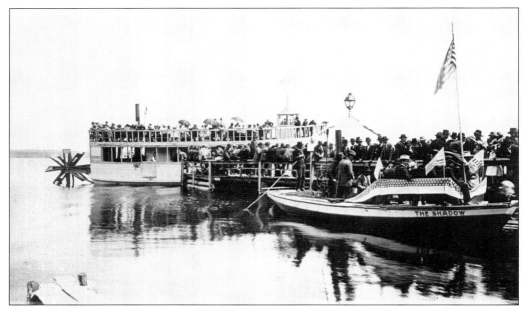

The Shadow was the scene of a tragedy on Lake Bemidji when it carried a large supply of fireworks for the 17th of May Norwegian celebration in 1901. The boat carried 24 young boys who were eager for the mock battle near Eighth Street. Sparks from a rocket ignited the explosives. Many suffered burns, and four drowned. Joe Michaud, Richard Zacharias, Fred Driver, Herbert Albrant, and Fred McCauley all died.

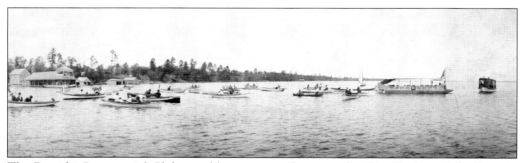

The Bemidji Commercial Club urged boaters to gather near the City Dock on Lake Bemidji for a photo shoot on July 11, 1906. Close to 30 launches and as many rowboats gathered for this photograph, which was intended for use in advertising the city's recreational benefits. This photograph was taken by the Hakkerup Studio located on Third Street.

The Elks State Convention was held in Bemidji in 1908. The City Boat Company made every boat available for the free use of visiting Elks and ladies during the convention. Rides around Lake Bemidji on Capt. W.B. "Mac" MacLachlan's big boat, the *North Star*, were also free. The famous Hibbing baseball team played against the Bemidji team, while a band of Red Lake Indians gave dances, held boat races, and camped along the lakeshore. Elks members sported new uniforms consisting of white duck Ulster coats reaching to six inches from the ground, white hats all trimmed with purple, a purple and white umbrella, white shoes, and purple spats. More than 80 uniforms were ordered for members to wear in the big parade. Below, a group of locals gather in front of a decorated window at the Challenge Hotel, at 417 Beltrami Avenue.

Seven saloons and about a million bedbugs burned in what was known as the fire on whiskey row, on the south side of Third Street on January 10, 1905. The blaze started about 6:00 a.m., with the government thermometer registering a temperature of 34 degrees below zero, and spread from the N.P. Saloon in the center of the block to envelop buildings on either side. The department tried valiantly to save the Brinkman Hotel, but it too was soon consumed by the flames. Of the 12 buildings on the south side of the street, six were entirely destroyed, two were badly damaged, and four were untouched. As the fire gained headway, the heat increased until it finally cracked plate glass windows in nearly every establishment on the north side of the street.

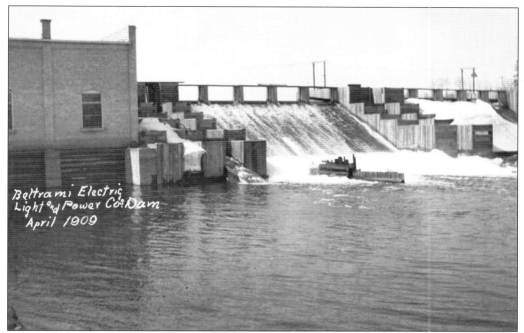

Beltrami Electric
Light and Power Co's Dam
April 1909

Beltrami Electric Light and Power Company and the Warfield Electric Company, owned by Charles and Andrew Warfield, built the Mississippi River Dam power plant in 1907, providing Bemidji with its first electric lights. The company started in business in 1899 with a power plant on Fourth Street. The Warfields sold their company to Minnesota Electric Light and Power in May 1915.

Work on the new federal building to house the Bemidji post office was started in the fall of 1917. Employees made the move to the new facility, at Sixth Street and Beltrami Avenue, on Sunday, July 14, 1918. Businessmen complained about the location, and postmaster Absie P. Ritchie promised additional mail receptacles to help those who were used to dropping their mail at Fourth Street and Beltrami Avenue.

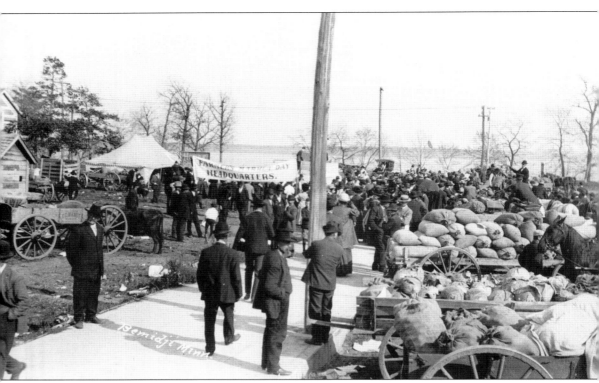

Bemidji's first Farmers' Market Day was held on October 12, 1911, along Fourth Street and up to Bemidji Avenue. Businessmen offered prizes as an incentive to come into the city. W.C. Schroeder, for example, offered a sack of Pillsbury's white flour to the farmer who brought in the most visitors from more than five miles away. Dr. Joseph McClure was chosen as the auctioneer, and a public auction was held for cows, horses, wagons, buggies, and produce. At one point, there were 75 wagons filled to capacity with produce, some pulled by four-horse teams and others by yokes of oxen, lined up at the auction ground. A public wedding was even held at 2:00 p.m., for Paul Utech of Turtle River and Mable Irish of Lavinia. The Webster Greenhouse furnished a dozen American Beauty roses for the bride. About 25 prizes were given to the bride and groom, including a wedding ring from Barker's Jewelry Store and a leather chair from the Majestic Theatre. The Brinkman Theatre gave $10 in gold to the couple.

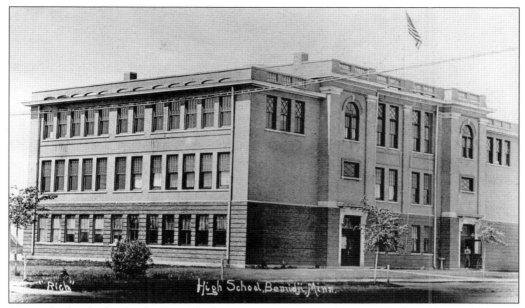

This is the first high school in Bemidji, facing America Avenue between Sixth and Seventh Streets. Construction began in 1908, and the school opened in the fall of 1910 at a cost of $50,000. A.P. Ritchie was its first superintendent. Prior to that, high school classes were held in the Central School, whose first graduating class, in 1903, included only three people.

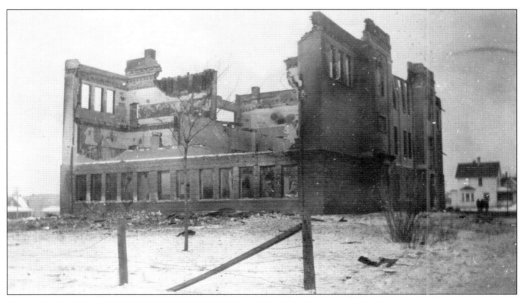

Fanned by a northwestern gale, the school was totally destroyed by fire on Sunday, January 16, 1921. The first alarm was given about 4:30 a.m., and in a very short time, the building was a furnace. Firemen were kept busy spraying water on the row of houses on the east side of America Avenue, owing to the extreme heat and the cinders that came from the fire.

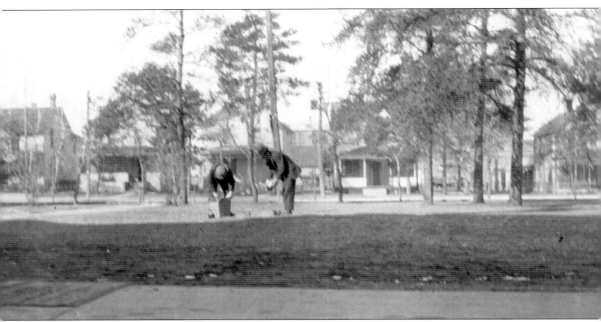

Before Prohibition was introduced at the national level, the federal government declared that Bemidji was in a territory that, under Indian treaty law of 1855, was not allowed to engage in the manufacture or sale of intoxicating beverages of any kind. In December 1914, the Federal Bureau of Indian Affairs ordered all saloons to cease and desist selling any liquor. A restraining order kept the Bemidji Brewery open until March 1915. When the order expired, however, government officials moved into town with special agents and dumped out beer valued at $4,500. Agents wading in six inches of beer opened other faucets and let the beer flow across the floor and into Lake Irving through drainpipes, entirely covering the shoreline with billows of foam. Here, on March 4, 1915, government Indian agents dump confiscated liquor on the courthouse lawn. Thus, Prohibition came to northern Minnesota five years before the nation experienced it. Bemidji lost many major businesses, but continued to grow.

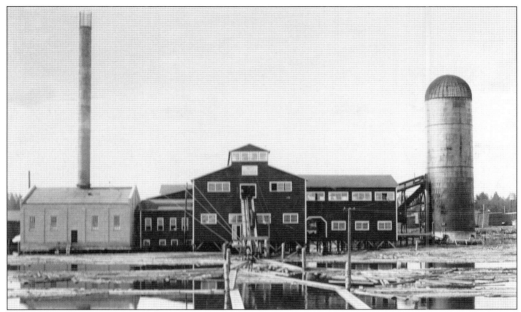

The Shevlin interests of Crookston Lumber Company purchased the Bemidji Lumber Company in 1914, and it became Crookston Mill No. 2. A major fire occurred on March 4, 1914, and the recently purchased property burned to the ground. The night watchman made his last visit at 4:30 a.m. and found no sign of smoke or fire. Albert Brabetz was the first to notice the flames, at 4:45 a.m. Just 15 minutes later, the entire building was in flames, and after two hours, the mill was in ashes. Cables on the smokestack became red with heat, but only one snapped, and the monster pipe remained standing. The mill was immediately rebuilt. Frank Warner confessed to arson two days later but later said that the confession was untrue. The night crew of the Bemidji Lumber Company is seen below in 1907.

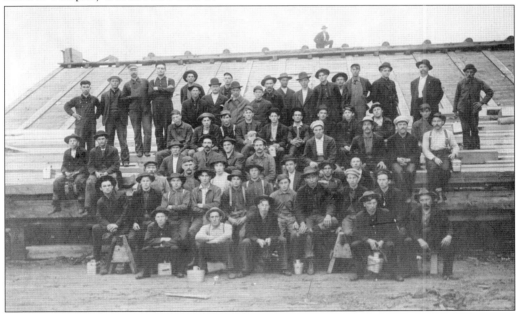

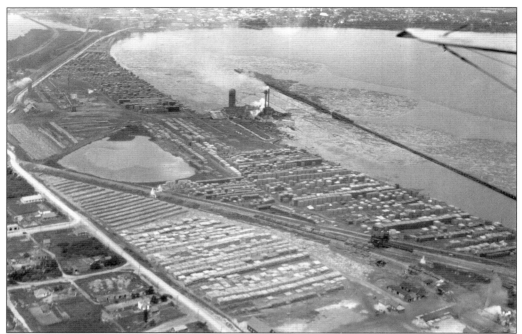

The aerial view above shows Crookston Lumber Mill No. 1 in 1923. On a hot, humid night on July 22, 1917, the mill burst into flame. The deep bass sound of the mill fire whistle brought most Bemidji families outside. Much of the mill was built over water, and within an hour, the men had restricted the fire to the mill itself. Rumors swirled about the possibility of arson and sabotage by the International Workers of the World (IWW). On November 8, 1924, a total of 24 million board feet of select white pine were destroyed in a second fire. In an interview, Charlie Naylor, a witness to the fire, said that once the fire started, there was no way to stop it. This mill was not rebuilt.

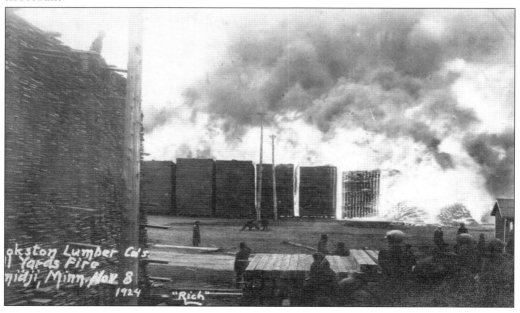

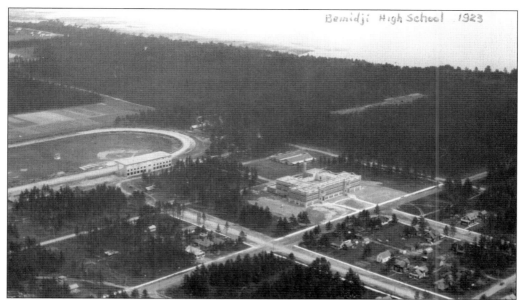

The aerial view above of Bemidji High School in 1923 also shows the Northern Minnesota Fairgrounds, including the racetrack and the grandstand, which was built in 1922. The *Bemidji Pioneer* boasted about the splendid grandstand facilities, which could accommodate several thousand visitors, writing, "Bemidji is prepared to take care of immense fair crowds and provide them with every comfort." The Works Progress Administration (WPA) approved a project to rebuild the grandstand bleachers at the fairgrounds, starting on May 16, 1938, and under the foremanship of Ed Rako, the president of the fair association. Repairs were made to the bandstand, the agricultural building, and some of the livestock barns. By this time, the grounds had been renamed the Beltrami County Fairgrounds. In 1940, a tremendous windstorm went through the fairgrounds and tore the roof off of the grandstand.

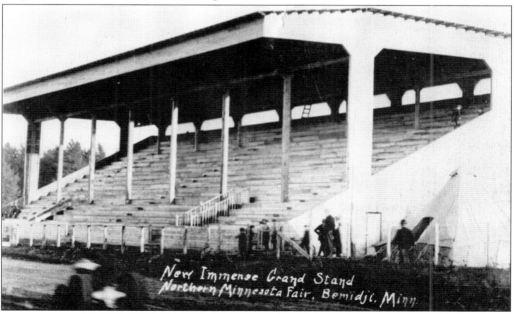

New Immense Grand Stand
Northern Minnesota Fair, Bemidji, Minn.

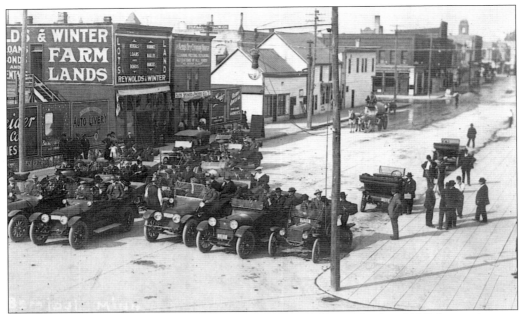

The photograph above shows businessmen exiting the Markham Hotel, at 210 Beltrami Avenue, and gathering in automobiles. Notice the white wooden building at the corner of Third Street and Beltrami Avenue, which was one of the pioneer buildings of Bemidji. The frame, two-story building suffered a fire in 1914, and a new brick front facing Third Street was constructed. The building was owned by John Dalton and burned in its entirety in a spectacular fire on December 21, 1916. It was rebuilt entirely of brick and housed Patterson Clothing for many years. Below, four Bemidji firemen celebrate the Fourth of July in 1922.

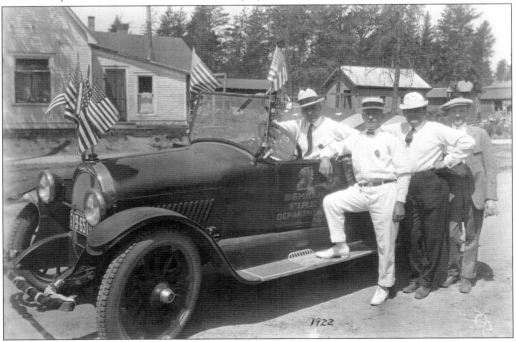

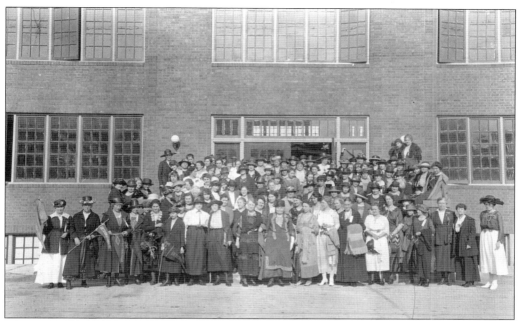

The Women's Benefit Association of the Maccabees gathered for this photograph at the original entrance of the new armory, facing Beltrami Avenue, on May 30, 1921. This entrance was eventually changed because it was too dangerous. The organization hosted an all-day program that included a display of ritual floor work by the Bemidji Guard Team, with Rose Olson as captain.

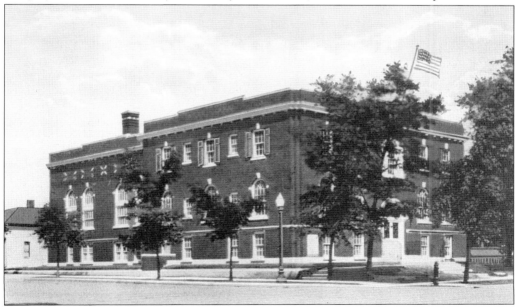

The Masons built their new three-story home at the corner of Fifth Street and Bemidji Avenue in the fall of 1923. It included a ballroom, a banquet hall, an auditorium, clubrooms for the Eastern Star, and card and billiard parlors that were eventually turned over to the Demolays. The Masonic temple was officially dedicated on April 23, 1924. C.L. Pegelow was the master of the local lodge.

DISCOVER THOUSANDS OF LOCAL HISTORY BOOKS FEATURING MILLIONS OF VINTAGE IMAGES

Arcadia Publishing, the leading local history publisher in the United States, is committed to making history accessible and meaningful through publishing books that celebrate and preserve the heritage of America's people and places.

Find more books like this at
www.arcadiapublishing.com

Search for your hometown history, your old stomping grounds, and even your favorite sports team.